★

ICONS

MARK

RD FIREWORKS INDUSTRIES,SIVAKAS

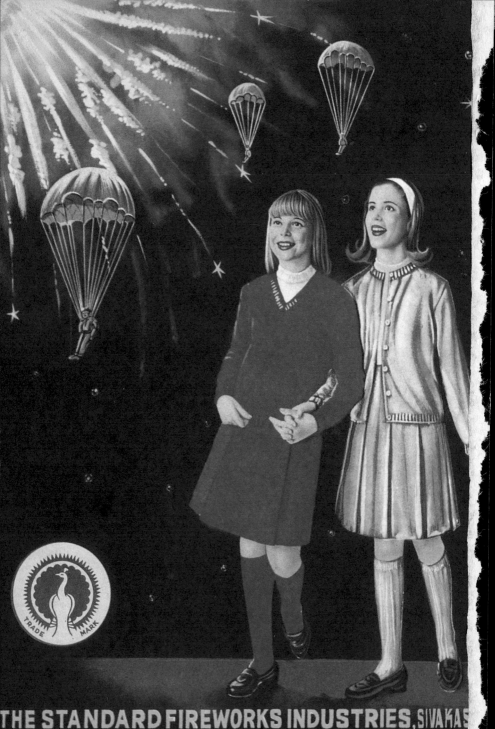

THE STANDARD FIREWORKS INDUSTRIES, SIVAKASI

INDIA BAZAAR

VINTAGE INDIAN GRAPHICS

Edited by

Samantha Harrison and Bari Kumar

Introduction by Kajri Jain

K LN LONDON LOS ANGELES MADRID PARIS TOKYO

Front cover: *Shiva and Parvati*, Framing picture
Back cover: *Mahishasurmardini (The Slayer of*
Mahishasur), Framing picture, JB Khanna Publishers
Endpapers: Fireworks labels
Right: *Sri Krishna Yamuna Paar (Krishna Crossing River*
Yamuna), Framing picture, Ravi Uday-Vijay Press,
Ghatkopar

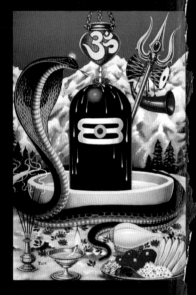

© 2003 TASCHEN GmbH
Hohenzollernring 53, D–50672 Köln
www.taschen.com

Notes about the text: Slight variations in spellings and
attributable are due to the myriad religions, languages and
regional dialects of India. Captions identifying works appear
at the end of the book, on pages 190–91.

Editor: Jim Heimann, Los Angeles
Cover and interior design: Coco Shinomiya, Los Angeles
Photos by: Artworks, Pasadena
Production: Tina Ciborowius, Cologne
Project management: Sonja Altmeppen, Cologne
English-language editor: Nina Wiener, Los Angeles
German translation: Clara Drechsler, Cologne
French translation: Philippe Safavi, Paris

Printed in Italy
ISBN 3–8228–2618–9

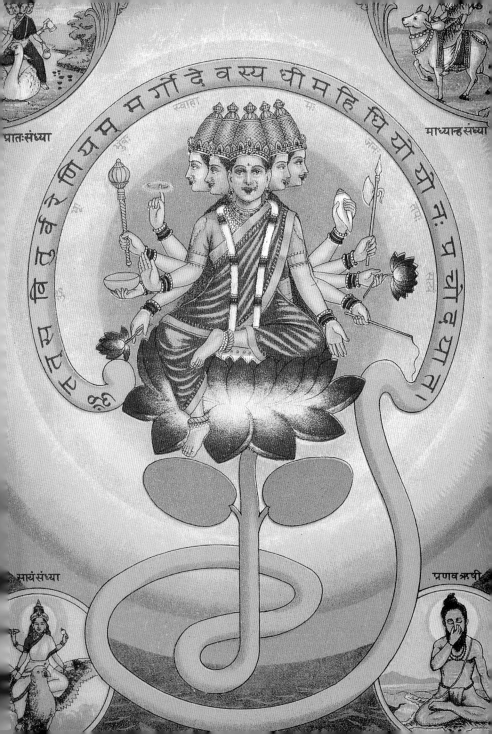

प्रातःसंध्या

माध्यान्हसंध्या

सायंसंध्या

प्रणव ऋषी

INDIA BAZAAR
by Kajri Jain

Luminous pink-cheeked gods, perpetually delighted children, Muslim shrines twinkling against calligraphic backdrops, heroes of the Indian independence movement glowing with nationalistic fervor, coy and enticing women, swans and monkeys, radios and keys —

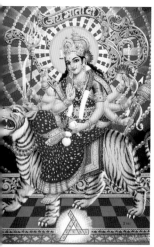

intense, graphic, suffused with lush colors, boldly centered within the frame. In India, printed images like these are available to almost everyone, either as small "framing pictures" that you can buy for a couple of rupees; as larger posters that cost a bit more; as packaging labels for inexpensive commodities like matches, incense and fireworks; or as calendars that are given away by businesses as advertisements. These commercially sold prints and inexpensive forms of local marketing, commonly referred to as "calendar art" or "bazaar art," have come to form a parallel image world to corporate-style agency advertising, fine art and craft or folk art (although there has been a certain amount of traffic between them all). Older chromolithographs and match labels have become collectors' items and are actually "vintage" graphics, while many of the other images on the pages that follow, particularly the framing pictures, are still in wide circulation.

Despite the common misconception, Indian calendar art is not a primarily urban form. Thriving on the low profit margins enabled by a truly mass market, it cuts across the city and the village, the street and the home, public and private, capitalist, bureaucrat, worker and peasant. It also blurs the boundaries between the realms of politics, commerce, religion and the aesthetic: calendar art and its sacred and secular iconographies appear in the public spaces of work and political spectacle as much as they inhabit the domestic sphere of kitchens, bedrooms and prayer rooms. They bob on the dashboards of buses and taxis; watch over government offices, schools and factories; hang from trees in outdoor markets or above cash registers in shops; animate political propaganda and advertising. Those without access to calendars, posters and framing pictures might even salvage pictures of deities from packaging labels to worship in their own personal shrines.

During India's colonial period (in the second half of the nineteenth century), images of deities as well as other mythological and secular subjects began to be commercially mass-produced. Many of these lithographs or oleographs were based on paintings by the most celebrated Indian artists of the day, such as Raja Ravi Varma (1848–1906), who were encouraged by British administrators and the Indian elite alike to use their training in Western artistic techniques to reinterpret Indian mythology. Indeed, the influence of Western naturalism is often more apparent in these early prints than in some of the later ones, which tend to revert to the more stylized iconography and formal postures associated with temple images used in ritual worship. Take, for instance, Matsya Avatar (p. 27), the first of the ten incarnations in which the Hindu god Vishnu came to save the world. Here Vishnu takes the form of a fish, which appears

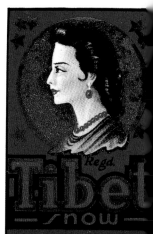

during a great deluge. In this early print, Vishnu is shown rescuing the four Vedas (Hindu holy books), which are depicted here through an unusual metaphor, as playful babies natur-alistically toying with the god's ornaments. In another early example, the relaxed posture of the elephant-headed deity Ganesh lounging on a riverbank (p. 34) provides a stark contrast to the later print (p. 35), which portrays a stiffer and more formal Ganesh before a white backdrop, his iconographic emblems placed carefully in three of his four hands — a goad for controlling elephants, a rope and a plate of sweets — leaving one hand for the gesture of blessing. Most Hindu gods are depicted with an animal who acts as their *vahana* or vehi-cle — a lion or tiger for the powerful mother goddess manifested variously as Kali, Durga (back cover), Amba or Vaishno Devi (p. 26); a goat for the local Gujarati mother goddess Meldi Mata (p. 25); Nandi the bull for Shiva or his wife Parvati (p. 24); the mythical Garuda bird for Vishnu (p. 22) — but in the case of the somewhat humorous Ganesh, his "vehicle" is the tiny mouse which appears in the foreground of both prints.

Some early publishers sent paintings to Germany and Austria to be lithographed, while Raja Ravi Varma set up his own lithographic press near Bombay (now Mumbai) with the assistance of a German technician in 1894; by then, other presses were already established in cities like Poona (Pune) and Calcutta (Kolkata). As is evident from the multiple versions here of Krishna *Stealing the Cowgirls' Clothes* (pp. 29–30), plagiarism was (and, in fact, still is) rampant. These presses supplied consumers all over the coun-try with framing pictures and posters through travelling agents operating in what historians have called the "bazaar" economy, a set of "informal" networks run by Indian trading communities linking colonial trade to Indian producers and consumers. Even after India achieved independence in 1947, this bazaar economy persisted as a parallel domain to the official state-led economy and a corporate sector largely controlled by an English-educated elite.

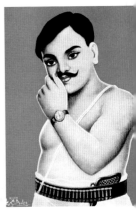

The early lithographs, which catered to a wider market than painted images, soon took on a political edge. The national visual language they created cut across India's multiple regional cultures, uniting Indians against British colo-nial rule by forging a widely recognizable common idiom. Religious and mytho-logical themes were soon supplemented with secular icons such as Mahatma Gandhi (p. 142) or the more militant nationalist revolutionaries Chan-drashekhar Azad (p. 151), Bhagat Singh (p. 159) and Subhash Chandra Bose (p. 152) (though the examples in this book are from more recent prints, still being sold today). But other images, such as the *Cow with 84 Gods* (pp. 44–45) published by the Ravi Varma Press, spoke to the interreligious conflicts that were often actively encouraged by British administrators as a tactic to divide anticolonial movements. Here the cow, considered sacred by Hindus, is depicted as containing eighty-four deities and providing milk to all communities alike, while the monster coming to slaughter the cow would have been understood to represent the meat-eating communities (particularly Mus-lims) against which it must be defended.

Above: Chandra Shekhar Azad; above left: Jaya Maata Di (Glory to the Mother Goddess); below left: Packaging design

While technological reproduction expanded the market for religious and mythological images, it did not create that market. The way had already been paved in the eighteenth and early nineteenth centuries by artist communities which produced images manually and sold them at popular pilgrimage centers like Kalighat in Calcutta, Nathdwara in Rajasthan and Puri in Orissa — as well as via the courts and bazaars, as was the case for Tanjore painting in the south of India. So one strand of bazaar art, that of images as commodities, dates back to when religious images first began to circulate in the marketplace, released from the power and control of priests. The other strand, that of religious images that enhance the allure of *other* commodities, emerged from the context of colonial trade wherein Indians

were targeted as consumers for the products of Britain's Industrial Revolution, particularly mill cloth. British trading firms – mostly owned by northern Protestants – were among the first to use Hindu religious imagery on textile labels to attract Indian consumers. Similarly, Swedish and Austrian match firms used Raja Ravi Varma's mythological images on matchbox labels aimed at the Indian market. While foreign firms dealt in a stereotypical idea of Indian religiosity, the examples in this book show that the Indian manufacturers emerging in the early decades of the twentieth century, producing their own textiles and matches and printing their own labels, had access to a far wider range of themes.

One early center for local Indian match production was the village of Sivakasi in South India, whose hot, arid climate was soon found to be conducive not only to the match industry but also to fireworks and printing. The phenomenal success of these three industries in Sivakasi has earned the town its reputation as a "mini Japan." Printing in Sivakasi began in 1928, with lithographed labels for the match and firework industries, and then extended to packaging and labels for other industries in the region. Soon after India achieved independence, Sivakasi's presses began to acquire high-volume offset machines, many of them bought secondhand or from East Germany, which (as part of the Socialist bloc with close ties to India) accepted payment in rupees. Sivakasi's printing industry, led by its entrepreneurial Nadar community, was able to achieve low costs through a combination of factors: the relatively low wages of skilled personnel; an ingenious mix of labor-intensive and mechanized processes (such as combining painting and photography in producing artworks and negatives); self-reliance and thrift in the use of technology and materials; and a decentralized system of ancillary services that kept overheads down. The organization of the calendar industry preempted today's decentralized forms of capitalism, skipping the stage of urbanization that accompanies the more familiar Euro-American story of modernity. By the mid-1960s, Sivakasi's color printing industry had optimized production costs to the extent that it could compete with presses in the major metropolitan centers, and by 1980 this still tiny township claimed to house forty percent of the entire country's offset printing capacity.

Above: Matchbox label; *below*: Firecracker label; *right*: Sri Mangalmurthy (Ganesh)

Again, despite Sivakasi's location at the extreme southern tip of India, the bazaar's network of agents has been able to ensure the extensive and intensive pan-national (as well as international) distribution of its products.

It should hardly come as a surprise, therefore, that nearly all the images in this book, except the older chromolithographs, were printed in Sivakasi. The older matchbox labels, dating from the 1930s to the 1960s, bear the traces of the lithographic process, with their bold black outlines, flat colors and dotted areas of shade. The more recent offset printed images are characterized by their brilliant, saturated colors, deep contrasts and strong highlights. These features are mostly achieved through extensive manual retouching of the color separations during the pre-press process, and by using extra red and blue plates in printing. Initially an attempt to compensate for technical problems, these characteristics have now become an essential part of the Sivakasi look; so much so that, even as Sivakasi's printers are switching to computerized scanning and separations, they often use software to achieve similar results.

This manipulation does not go down very well with the artists who paint the original images. As one senior artist, Yogendra Rastogi from Meerut, commented, "... even if it's the god Ram they'll give him [the actress] Saira Bano's lipstick — I didn't put it there!". Several calendar artists have been trained at the British-instituted art schools in Mumbai, Chennai (formerly Madras) or Kolkata, even though they might be familiar with other pictorial traditions. For instance, Indra Sharma (b. *circa* 1925) from the painter community in the pilgrimage town of Nathdwara studied at Mumbai's prestigious Sir Jamsetji Jeejeebhoy School of Art (JJ for short) in the 1950s, and now divides his time between Mumbai, Nathdwara and the U.S., where his daughter lives. Nathdwara artists have supplied pictures to the calendar and framing picture industry since the 1920s (see, for instance, *Virat Swaroop* by M. K. Sharma, p. 23), while continuing to foster a tradition of temple murals, miniatures and devotional paintings for sale to pilgrims. Venkatesh Sapar (b. 1967), arguably one of India's most prolific and versatile contemporary calendar artists, and his wife Maya, who assists him, were both trained in the 1980s at JJ before going back to the provincial center of Sholapur to carry on the calendar painting business started by his father and uncle.

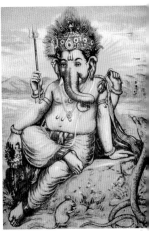

So these popular images are often made by people trained within a Western-derived art tradition which, having existed in India for over a century, must now be counted as an Indian tradition like the others on which they draw. What this means, among other things, is that such artists are painfully aware of the perspective from which market-driven calendar art is seen as a degraded, vulgar, commercial form, as "kitsch". However, even as they consciously negotiate between traditions, their calendar images are seldom ironic or self-mocking (as might be the case when such pictures are used by designers on T-shirts and handbags). Calendar artists take the marketplace and the dictates of religious iconography very seriously, for their livelihood depends on them.

While each of these images does bear the stamp of the artist who created it, and publishers do distinguish between "creative" artists and "hacks", the value system in which calendar art circulates is not primarily one that celebrates the creativity of particular artists (as in the case of "fine" art). Most consumers of calendar art do not choose a print according to its artist but its subject (indeed, most people would be hard put to name a single calendar artist other than Ravi Varma). From this point of view, the formal characteristics of Sivakasi's iconic prints need to be understood in relation not so much to artistic originality but to other criteria of value and power, particularly their auspiciousness: their ability to bless and bring good fortune to those who fall under their gaze. Stemming from the belief that it is as important to be seen by an icon as it is to see it, calendar deities face the viewer directly out of the center of the frame, their heads slightly larger than normal in proportion to the rest of the body, and their eyes, from which their divine benevolence is thought to flow, given great prominence. Several of the deities in this book have a right hand raised in a gesture of blessing (e. g. Vaishno Devi, p. 26; Meldi Mata, p. 25; Santoshi Mata, p. 180; Shiva and Parvati, cover). The benevolence expressed by icons towards their devotees is of the utmost importance; thus, naturalism of technique is concentrated in the figures' eyes and facial expressions. Little attempt is made at realistic perspective in the composition as a whole, where size and placement are determined by the relative importance of the figures or narrative sequence.

Take, for instance, the print used in the Hindu ritual of *karva-chauth*, where women pray to Ganesh for the well-being of their husbands (p. 47). Here, the largest figure is that of Lakshmi, the goddess of wealth, but superimposed on her in a central circle is the family of

Shiva, Parvati and their sons Ganesh and Kartikeya, who are as important as Lakshmi in this context, if not more so. The smaller peripheral figures are devotees and figures from the myth of *karva-chauth*. On the other hand, in *Virat Swaroop* (p. 23), the central figure is both important and physically enormous, as this print depicts the moment from the epic story of the Mahabharata or "great war" when Krishna reveals himself in his omnipotent form, in which the entire universe can be seen. Here Krishna appears with all the other gods embedded in his body, while the small figure kneeling before him is the warrior Arjuna. Smaller and

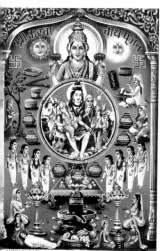

to the right of the frame we see the same two figures just before the revelation, as Krishna addresses Arjuna with the famous ethical sermon known as the Bhagavad Gita, to help him overcome his crisis of conscience at going into battle against his own cousins.

Not all these images are benevolent icons, however, nor do they all depict anthropomorphic deities. The "*karni-bharni*" or "deeds and punishments" posters (p. 158) issue dire graphic warnings to those considering adultery, cheating, bribery, abortion, greed, theft and overloading their animals. There is an image of the rampaging mother goddess Kali accidentally stepping on her sleeping husband Shiva in a blind rage (p. 31). Or there is a print celebrating the 1757 martyrdom of the Sikh warrior-saint Baba Deep Singh, who challenged the Afghan ruler Ahmad Shah's occupation of Amritsar in Punjab (p. 49). Having vowed before the battle that he would only die when he got to Harminder Sahib (the Sikhs' Golden Temple in Amritsar), legend has it that even when he was decapitated he held onto his head and continued to fight until he got close to the temple, finally rolling it the last few hundred yards to the temple entrance. Prints on this theme became particularly popular after 1984, when the Indian army raided the Golden Temple in an attempt by the then Prime Minister Indira Gandhi to assert the central government's authority over Sikh militants demanding a separate homeland. (The temple was being used as a hideout and a cache for weapons; six or seven hundred militants and eighty soldiers were killed in the attack, and Indira Gandhi was assassinated four months later.) Another scene of martyrdom, this time from the Islamic tradition, depicts the encampment at Karbala in Iraq where the prophet Mohammed's grandson Hussain was killed for his refusal to pay allegiance to the Caliph Yazid (pp. 54–55). Given the injunction against icons in Islam, there are no holy figures in this scene, only Hussain's faithful horse Duldul. Human figures are not proscribed altogether in South Asian Islamic images, however, and so, for instance, there are prints depicting people at prayer (pp. 52 and 53).

Most prints on Muslim themes achieve their visual intensity not through the depiction of benevolent or malevolent emotion but through color, the ornamental use of calligraphy (eg. p. 59) and the important symbolic element of light (*noor*) which suffuses the images in the form of rays, sparkles, highlights and glowing gems (eg. p. 56). Particularly characteristic of Islamic prints are images of sacred shrines and pilgrimage sites such as Mecca, Medina, Ajmer Sharif or Haji Malang near Mumbai (p. 58), which appears here on a kind of pilgrim's map depicting the stages of the journey, the important landmarks and the various modes of transport used to get there. This shrine of a Muslim saint has been

Above: Kanwa Chowth; below: Matchbox label; right: Allah

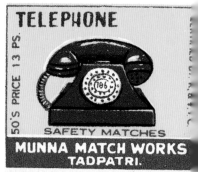

sacred to Hindu, Muslim, Christian and Parsi (Zoroastrian) pilgrims alike, and for generations a Brahmin family has looked after its upkeep; Haji Malang was often proudly cited as a symbol of the coexistence and melding of India's syncretic traditions, until Hindu nationalists attempted to reclaim it as a Hindu shrine in 1996.

Not just deities, pilgrimage sites and religious symbols, but also secular icons such as nationalist heroes, demure brides and healthy children, are drawn into the visual regime of auspiciousness. So are signs of modernity and progress, often equated with Westernization. Notice that children, symbols of the future, are almost always in Western clothing (eg. pp. 60–63, 144, 153, etc.), except when representing the diverse regional cultures within India (p. 157). The task of maintaining cultural "traditions" in the face of this modernity most commonly falls, however, to the figure of the "good" Indian woman; so, when confident couples look out from the firework labels celebrating a sparkling vision of progress and development (p. 64), he wears Western clothes and she a *sari*. In a country where for many people technological modernity has been more accessible as an image than as reality, even seemingly banal objects such as televisions and radios, or scenes of city life (p. 188), take on a mythical aura. So, for instance, the label for Telephone safety matches (p. 104) displays the well-known lucky number 786, numerologically derived from the first line of the Koran. Nowhere is this utopian modernity more poignantly evident, however, than in the educa-

tional charts which are also printed in Sivakasi and still used in schools all over the country. They are prescriptions not just for "An Ideal Boy" (p. 149) but for an ideal nation; here, little boys with neatly parted hair eat plenty of fruit and vegetables (remembering to chew well), there are only three people in the queue for tickets at the bus station and everyone is expected to identify an electric shaver in two languages.

Today you do not need to travel too far to encounter these Indian icons: their adoption by "global" culture has meant that Krishna and Kali, Duldul and Baba Deep Singh, the Ideal Boy and Chandrashekhar Azad have appeared on CD covers, diaries, websites, clothing and fashion accessories from New Delhi to New York. These appropriations respond to the inescapable visual power of these images, with their vivid colors, bold graphic forms and obviously rich and complex symbolism. As they journey to these other contexts and take on new incarnations, however, something is inevitably left behind: the countless interwoven stories of what these images represent, who creates them and the many mutable ways in which they have inhabited and animated millions of everyday lives.

India Bazaar
von Kajri Jain

Von innerem Leuchten erfüllte, rosenwangige Götter, entzückte Kinder, muslimische Heilig-tümer, Helden der indischen Unabhängigkeitsbewegung, in denen das patriotische Feuer glüht, keusche und lockende Frauen, Schwäne und Affen, Radios und Schlüssel, knallbunt, plastisch und in satten Farben: Derartige Drucke sind in Indien fast an jeder Ecke zu bekom-men, als Bildchen zum Einrahmen (so genannte *framing pictures*), die man für ein paar Rupien kaufen kann, als größere Poster, die etwas mehr kosten, als Verpackungsaufkleber

für billige Allerweltsartikel wie Streichhölzer, Räucherstäbchen und Knallfrösche, oder als Kalender, die von Geschäften als Werbege-schenke verteilt werden. Die »Kalendermalerei« oder »Basarkunst« bildet mittlerweile eine eigenständige Bildwelt neben der Profi-Wer-bung im Stil der großen Agenturen, neben Kunst und Kunstgewerbe oder Volkskunst (wobei die Übergänge fließend sind). Alte Chromo-lithografien und Etiketten von Streichholzschachteln sind mittlerwei-le gesuchte Sammlerstücke und echte Raritäten, während viele der Bilder auf den folgenden Seiten noch in Umlauf sind.

Anders als oft angenommen, ist indische Kalenderkunst keines-wegs ein rein urbanes Phänomen. Das Geschäft mit einer solchen echten Massenware lohnt sich auch bei geringen Profitmargen und das gilt für Stadt wie Dorf, Straße wie Zuhause, Öffentlichkeit wie Pri-vatsphäre. Zwischen Politik, Kommerz, Religion und Ästhetik lässt sich in der Kalendermalerei kaum noch unterscheiden: Die heiligen

Above: Packaging label; *below*: *Matsya Avatar (Fish Incarnation)*; *right*: *Gopi Vastraharan (Stealing the Cowgirls' Clothes)*

wie auch die profanen Bildwerke finden sich in den öffentlichen Räumen ebenso wie in der häuslichen Sphäre von Küche, Schlafzimmer und Gebetsräumen. Sie wachen über Regie-rungsbüros, Schulen und Fabriken; sie hängen auf Märkten von den Bäumen oder in Geschäften über der Kasse; sie bringen Leben in die politische Propaganda und in die Wer-bung. Wer sich keine Kalender, Poster und *framing pictures* beschaffen kann, hebt sogar die Aufkleber mit Heiligenbildchen von den Verpackungen auf und bestückt damit seine Haus-altäre.

Während der indischen Kolonialzeit in der zweiten Hälfte des 19. Jahrhunderts wurden Bilder von Göttern und anderen mythischen oder weltlichen Ikonen zum ersten Mal als Massenprodukte hergestellt. Viele dieser Lithografien oder Oleografien basierten auf Gemälden von namhaften indischen Künstlern der damaligen Zeit – so etwa von Raja Ravi Varma (1848–1906) –, die mit westlichen Darstellungsweisen vertraut waren und von britischen Verwaltungsbeamten und der indischen Elite angehalten wurden, ihre Kenntnisse zu nutzen, um The-men aus der indischen Mythologie neu zu interpretieren. Der Einfluss des westlichen Naturalismus ist in diesen frühen Drucken oft sogar viel augenfälliger als bei eini-gen der späteren, die sich wieder auf die stilisierte Iko-nografie besinnen, wie man sie von den Tempelbildern kennt, die bei Kulthandlungen benutzt werden. Ein gutes Beispiel ist Matsya Avatar (S. 27), die erste der zehn

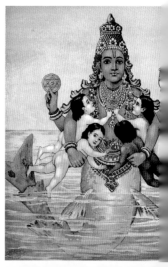

Inkarnationen, in denen der Hindugott Vishnu auftrat, um die Welt zu retten. Hier erscheint Vishnu in Gestalt eines Fischs während einer verheerenden Flut. Der frühe Kunstdruck zeigt Vishnu bei der Bergung der vier Veden (die heiligen Schriften des Hinduismus), die hier jedoch in ungewöhnlicher Bildsprache als vier muntere Babys dargestellt sind. Auf einem anderen frühen Beispiel lagert der elefantenköpfige Gott Ganesha in entspannter Haltung an einem Flussufer (S. 34), ein deutlicher Gegensatz zu dem späteren Druck (S. 35), der einen formelleren Ganesha vor weißem Hintergrund zeigt, dem man die ikonografischen Embleme – einen Stachelstock für Elefantentreiber, ein Fangseil und einen Teller mit Naschwerk – ordentlich in drei seiner vier Hände gegeben hat, damit eine Hand frei bleibt, um den Segen zu spenden. Die meisten Hindugötter werden mit einem Tier abgebildet, das ihnen als *vahana* oder Reittier dient – ein Löwe oder Tiger für die mächtige Muttergottheit in ihren verschiedenen Manifestationen als Kali, Durga (Umschlagrückseite), Amba und Vaishno Devi (S. 26); eine Ziege für die in Gujarati verehrte Muttergottheit Meldi Mata (S. 25); Nandi, der Bulle, für Shiva oder seine Frau Parvati (S. 24); der mythische Vogel Garuda für Vishnu (S. 22). Und das Begleittier des eher humoresken Ganesha ist die winzige Ratte, die auf beiden Drucken im Vordergrund zu sehen ist.

Anfangs schickten einige Verlage ihre Bilder nach Deutschland oder Österreich, um dort die Lithografien anfertigen zu lassen, aber Raja Ravi Varma nahm 1894 in der Nähe von Bombay (heute Mumbai) mit der Hilfe eines deutschen Technikers seine eigene lithografische Druckpresse in Betrieb; weitere Druckpressen existierten damals schon in Städten wie Poona (Pune) und Kalkutta (Kolkata). Wie man an den diversen Versionen von *Krishna stiehlt die Kleider der Viehhirtinnen* (S. 29–30) unschwer erkennen kann, war (und ist) plagiieren eine gängige Praxis. Diese Druckereien belieferten über Handelsreisende Kunden im gesamten Land mit *framing pictures* und Kunstdrucken; Historiker sprechen von »Basarwirtschaft«, informellen Netzwerken von indischen Handelsgesellschaften, die das Bindeglied zwischen kolonialem Handel sowie indischen Produzenten und Verbrauchern bilden. Selbst nachdem Indien 1947 unabhängig wurde, überlebte diese Basarwirtschaft neben der offiziellen, staatlich gelenkten Wirtschaft und einer Geschäftswelt, die hauptsächlich von der in England ausgebildeten Elite kontrolliert wurde.

Die frühen Lithografien, die eine größere Verbreitung fanden als Gemälde, gewannen bald auch eine politische Bedeutung. Die nationale Bildsprache, die sie schufen, gab den zahllosen regionalen Kulturen Indiens ein gemeinsames, überall verständliches Idiom und einte die Inder auf diese Weise gegen das britische Kolonialregime. Zu den religiösen und mythologischen Motiven kamen bald säkulare Größen wie Mahatma Gandhi (S. 142) oder die militanteren nationalistischen Revolutionäre Chandrashekhar Azad (S. 151), Bhagat Singh (S. 159) und Subhash Chandra Bose (S. 152) hinzu (die hier abgebildeten Beispiele sind allerdings neueren Datums und werden heute noch verkauft). Andere Bilder wiederum, zum Beispiel *Kuh mit 84 Göttern* (S. 44–45), erschienen bei Ravi Varma Press, sprachen die interreligiösen Konflikte an, die von der britischen Verwaltung oft noch geschürt wurden, um antikolonialistische Bewegungen zu spalten. Hier trägt die Kuh, die den Hindus heilig ist, 84 Götter in sich und säugt unterschiedslos alle Glaubensgruppen, während die Ungeheuer, die sich nähern, um die Kuh zu schlachten, die Fleisch essenden Glaubensgruppen (vor allem die Moslems) darstellen sollen, gegen die sie verteidigt werden muss.

Die technische Reproduzierbarkeit hat den Markt für Bilder mit religiösen und mythologischen Motiven erweitert, aber geschaffen hat sie diesen Markt nicht. Eine Spielart der

Basarkunst, bei der die Bilder die eigentliche Ware sind, geht auf die Zeit Ende des 18., Anfang des 19. Jahrhunderts zurück, in der religiöse Bilder erstmals frei verfügbar waren und somit der Macht und der Kontrolle der Priesterschaft entzogen wurden. Die andere Spielart, nämlich religiöse Bilder, die *andere* Waren attraktiver machen sollen, ergab sich aus dem Kontext des Kolonialhandels, der die Inder als Endverbraucher von englischen Produkten erreichen wollte. Doch britische Textilhandelsgesellschaften oder schwedische und australische Streichholz-Hersteller hatten bei der Gestaltung etwa von Etiketten recht stereotype Vorstellungen von indischer Religiosität. Die indischen Fabrikanten hingegen, die sich in den ersten Jahrzehnten des 20. Jahrhunderts etablierten, eigene Textilien und Streichhölzer produzierten und dafür selbst Etiketten druckten, verfügten über eine sehr viel breitere Auswahl an Motiven.

THE STANDARD FIREWORKS
INDUSTRIES, SIVAKASI.

Ein frühes Zentrum der indischen Streichholzproduktion war die Kleinstadt Sivakasi in Südindien, wo sich das heiße, trockene Klima nicht nur für die Streichholzproduktion, sondern ebenso für die Herstellung von Feuerwerkskörpern und die Ansiedlung von Druckereien anbot. Der phänomenale Erfolg dieser drei Industrien in Sivakasi hat der Stadt ihren Ruf als »Klein-Japan« eingetragen. Die ersten Druckereien gab es in Sivakasi 1928, als man zunächst lithografierte Etiketten für die Streichholz- und Feuerwerkskörper-Fabrikation herstellte und dann das Geschäft auf Verpackungen und Etiketten für andere Gewerbe in der Region ausdehnte. Kurz nachdem Indien unabhängig geworden war, investierten die Druckereien in Offsetdruckmaschinen, die für die Massenproduktion tauglich waren. Sie wurden größtenteils gebraucht gekauft oder aber in der DDR, die gute Kontakte zu Indien pflegte und die Zahlung in Rupien akzeptierte. Dass die Druckindustrie in Sivakasi, allen voran die geschäftstüchtige Nadar Community, so kostengünstig produzieren konnte, lag an einer ganzen Reihe von Faktoren: den relativ niedrigen Löhnen für ausgebildete Arbeitskräfte, dem ausgeklügelten Ineinandergreifen von arbeitsintensiven und mechanisierten Prozessen, dem Selbstvertrauen und der Sparsamkeit im Umgang mit Technologien und Materialien sowie dem dezentralisierten System von Zulieferern, das die Fixkosten überschaubar hielt. Die Organisationsstrukturen der Kalenderindustrie nahmen die heutigen dezentralisierten Formen des Kapitalismus vorweg und übersprangen dabei einfach das Stadium der Urbanisierung, das die uns vertrautere, euro-amerikanische Geschichte der Moderne begleitete. Bis Mitte der 60er hatte Sivakasis Farbdruckindustrie die Produktionskosten so weit optimiert, dass sie mit Druckereien in den größeren städtischen Ballungsräumen konkurrieren konnte, und 1980 konnte sich dieses immer noch kleine Städtchen rühmen, 40 Prozent der Offsetdruckkapazität des gesamten Landes zu vereinen. Auch hier ist es dem Basarnetzwerk von Handelsreisenden trotz Sivakasis Lage im äußersten Süden Indiens gelungen, den nationalen (und internationalen) Vertrieb der dort hergestellten Produkte sicherzustellen.

Es sollte daher nicht überraschen, dass nahezu alle Bilder in diesem Buch, von den älteren Chromolithografien abgesehen, in Sivakasi gedruckt sind. Die älteren Streichholzschachtel-Etiketten, die aus den 30ern bis 60ern datieren, zeigen deutliche Merkmale des lithografischen Verfahrens – die breiten schwarzen Konturen, die verwaschenen Farben und die Passerungenauigkeiten. Charakteristisch für die jüngeren Offsetprints sind ihre brillanten Farben, starken Kontraste und markanten Highlights.

CANDLE

PRICE Re. 0·04

PEEVY MATCHE

Dieses Erscheinungsbild entsteht hauptsächlich durch eine aufwändige Bildbearbeitung in der Druckvorstufe und durch die Verwendung von Sonderfarben. Solche Merkmale sind mittlerweile ein so unverzichtbarer Bestandteil des Sivakasi-Looks, dass die dortigen Druckereien selbst nach der Umstellung auf Computer-Scanning und -Farbauszüge oft eine Software benutzen, die ähnliche Effekte ermöglicht.

Die Maler der Originalvorlagen sind von diesen Überarbeitungen nicht immer begeistert. So meint zum Beispiel Yogendra Rastogi, ein erfahrener Maler aus Meerut: »... selbst wenn es der Gott Ram ist, malen sie ihm die Lippen an wie Saira Bano (eine Schauspielerin) – von mir ist das nicht!« Viele Kalendermaler haben ihre Ausbildung nach englischem Vorbild erhalten. Indra Sharma (geb. um 1925) aus der Malergruppe in der Pilgerstadt Nathdwara studierte zum Beispiel in den 50ern an der renommierten Sir Jamsetji Jeejeebhoy School of Art (kurz JJ genannt) und pendelt jetzt zwischen Mumbai, Nathdwara und Amerika, wo seine Tochter lebt. Künstler aus Nathdwara liefern seit 1920 Bilder an die Kalender- und *framing pictures*-Industrie (siehe zum Beispiel *Virat Swaroop* von M. K. Sharma, S. 23), widmen sich daneben aber nach wie vor auch Wandmalereien für Tempel oder Miniaturen zum Verkauf an Pilger. Venkatesh Sapar (geb. 1967), unbestritten einer der produktivsten und vielseitigsten zeitgenössischen Kalendermaler, und seine Frau und Assistentin Maya haben beide in den 80ern am JJ studiert, ehe sie in das Provinzzentrum Sholapur zurückkehrten, um das Kalenderbilder-Geschäft zu übernehmen, das Sapars Vater und Onkel gegründet haben.

Diese populären Bilder werden also oft von Künstlern gemalt, die mit einer westlichen Kunsttradition vertraut sind, die in Indien seit einem Jahrhundert vertreten ist, so dass sie längst ebenfalls als indische Tradition zu betrachten ist. Dies bringt unter anderem mit sich, dass den Künstlern ständig jene Perspektive peinlich gegenwärtig ist, aus der die marktorientierte Kalenderkunst als »Kitsch« erscheinen muss. Doch selbst wenn sie sehr bewusst mit den verschiedenen Traditionen arbeiten, sind ihre Kalenderbilder nie ironisch oder distanziert (wie es der Fall wäre, wenn Designer ähnliche Bilder für T-Shirts und Handtaschen benutzten). Kalendermaler nehmen den Markt und das Diktat der religiösen Ikonografie sehr ernst, weil davon ihr Lebensunterhalt abhängt.

Obwohl jedes dieser Bilder die Signatur des Künstlers trägt und die Verleger zwischen »kreativen Künstlern« und »Gebrauchsmalern« unterscheiden, wird in der Kalenderkunst nicht unbedingt die individuelle Kreativität eines Malers gewürdigt (wie es bei »richtiger« Kunst der Fall ist). Die meisten Käufer von Kalenderkunst suchen sich einen Druck nicht wegen des Künstlers, sondern nach dem Bildgegenstand aus. Wenn man es so betrachtet, kommt es bei der formalen Beurteilung der Drucke aus Sivakasi weniger auf künstlerische Originalität als auf ganz andere Kriterien an, besonders auf ihre Funktion als Segensspender für alle, die ihnen unter die Augen treten. Es ist nämlich ebenso wichtig, von der Ikone gesehen zu werden, wie sie zu sehen – darum blicken Kalender-Gottheiten immer genau aus der Bildmitte heraus auf den Betrachter. Ihre Köpfe sind ein wenig zu groß in Proportion zu ihrem Körper, und ihre Augen, denen die göttliche Mildtätigkeit entströmen soll, sind stark betont. Mehrere der Gottheiten in diesem Buch haben die rechte Hand zu einer segnenden Geste erhoben (z. B. Vaishno Devi, S. 26; Meldi Mata, S. 25; Santoshi Mata, S. 180; Shiva und Parvati, Umschlagvorderseite). Das Wohlwollen, das diese Ikonen ihren Gläubigen gegenüber ausdrücken, ist von äußerster Wichtigkeit, darum konzentriert sich die naturalistische Darstellung besonders auf die Augen und den Gesichtsausdruck der Figuren. Bei der Gesamtkomposition legt man nicht so sehr Wert auf eine realistische Perspektive; dort werden Größe und Anordnung von der Bedeutung der Figuren oder der geschilderten Episode bestimmt.

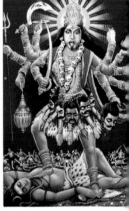

Above: Mahakali;
above left:
Fireworks label;
below left:
Matchbox label

Ein Beispiel dafür ist das Bild, das bei dem hinduistischen Ritual *karva-chauth* verwendet wird, mit dem Frauen für das Wohlergehen ihrer Männer zu Ganesha beten (S. 47). Hier ist die größte Figur Lakshmi, die Göttin des Reichtums, doch in einem Kreis im Zentrum sind Shiva, Parvati und ihre Söhne Ganesha und Kartikeja angeordnet, die in diesem Kontext ebenso wichtig sind wie Lakshmi, wenn nicht wichtiger. Die kleineren Gestalten am Rand stellen Andächtige und Figuren aus dem *karva-chauth*-Mythos dar. In einer anderen Darstellung mit dem Titel *Virat Swaroop* (S. 23) ist die zentrale Gestalt so wichtig wie riesenhaft,

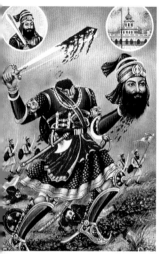

denn hier wird jener Moment in dem Epos des *Mahabharata* oder »großen Kriegs« gezeigt, in dem Krishna sich in seiner Omnipotenz zu erkennen gibt und das gesamte Universum sichtbar wird. Krishna vereint alle anderen Götter in sich, und die kleine, vor ihm kniende Gestalt ist der Krieger Arjuna. Kleiner und weiter rechts im Bild sehen wir dieselben beiden Gestalten kurz vor der Offenbarung, während Krishna Arjuna das berühmte philosophische Gedicht *Bhagavad Gita* vorträgt, um dessen Gewissensqualen vor dem Kampf gegen seine eigenen Vettern zu zerstreuen.

Nicht alle diese Bilder sind jedoch Glück verheißende Ikonen. Die *karni-bharni*- oder »Vergehen und Strafen«-Plakate (S. 158) sind düstere, drastische Warnungen an alle, die sich mit Gedanken an Unzucht, Ehebruch, Bestechung, Abtreibung, Geldgier, Diebstahl oder das zu schwere Beladen ihrer Lasttiere tragen. Ein Bild zeigt die wütende Muttergottheit Kali, die in ihrem blinden Zorn versehentlich auf ihren schlafenden Gatten Shiva tritt (S. 31). Ein anderer Druck verewigt den Märtyrertod des Sikh-Kriegers und Heiligen Baba Deep Singh, der sich 1757 dem afghanischen Herrscher Ahmad Shah entgegenstellte, der die Stadt Amritsar im Punjab besetzt hatte (S. 49). Der Legende nach hatte Baba Deep Singh vor der Schlacht gelobt, nicht zu sterben, ehe er nicht Har-

minder Sahib, den Goldenen Tempel der Sikhs in Amritsar, erreicht habe. Noch nachdem er bereits enthauptet worden war, soll er seinen Kopf festgehalten, sich den Weg bis kurz vor dem Tempel freigekämpft und den Kopf dann die letzten Meter über die Schwelle gerollt haben. Drucke mit diesem Motiv wurden besonders populär, nachdem die indische Armee 1984 den Goldenen Tempel gestürmt und die damalige Premierministerin Indira Gandhi versuchte hatte, die Autorität der Zentralregierung gegenüber militanten Sikhs durchzusetzen, die einen unabhängigen Staat forderten. (Der Tempel diente als Versteck und Waffenlager; bei dem Angriff starben 600 oder 700 Militante und 80 Soldaten, Indira Gandhi fiel vier Monate später einem Anschlag zum Opfer.) Ein anderes Märtyrermotiv, diesmal aus der islamischen Tradition, zeigt das Heerlager bei Karbala im Irak, wo Hussein, der Enkel des Propheten Mohammed, getötet wurde, weil er sich weigerte, dem Kalifen Yazid Gefolgschaft zu schwören (S. 54–55). Wegen des Bilderverbots im Islam sieht man in dieser Szene keine Heiligen, sondern nur Husseins treues Ross Duldul. Die islamischen Malereien Südasiens verbieten jedoch nicht rigoros jede Abbildung von Menschen, und so zeigen einige Drucke Betende (S. 52 und 53).

Die meisten Drucke mit islamischen Motiven beziehen ihre visuelle Überzeugungskraft nicht aus der bildlichen Um-

setzung von Emotionen, sondern durch Farbe, die ornamentale Verwendung von Kalligrafie (z. B. S. 59) und das wichtige symbolische Element des Lichts (*noor*), das die Bilder in Form von Strahlen, Funken, Schlaglichtern und blitzenden Edelsteinen durchdringt (S. 56). Besonders charakteristisch für islamische Drucke sind Bilder von Heiligtümern und Pilgerstätten wie Mekka, Medina, Ajmer Sharif oder Haji Malang bei Mumbai (S. 58), das hier auf einer Art Pilgerkarte erscheint, in die alle Stationen der Reise, die wichtigsten Wahrzeichen auf dem Weg und die verschiedenen Transportmittel dorthin eingezeichnet sind. Dieses Grabmal eines muslimischen Heiligen ist hinduistischen, muslimischen, christlichen und parsischen (zoroastrischen) Pilgern gleichermaßen heilig, und für die Instandhaltung ist seit Generationen eine Familie von Brahmanen verantwortlich. Haji Malang wurde oft mit Stolz als Symbol der Koexistenz und wechselseitigen Durchdringung von Indiens synkretistischen Traditionen angeführt, bis hinduistische Nationalisten ihn 1996 als Hindu-Schrein für sich reklamieren wollten.

Nicht nur Gottheiten, Pilgerstätten und religiöse Symbole, auch weltliche Ikonen wie Nationalhelden, sittsame Bräute und gesunde Kinder werden dem Gebot der Glücksverheißung unterworfen, ebenso wie Zeichen für Modernität und Fortschritt, die oft mit einer Verwestlichung gleichgesetzt werden. So treten Kinder, das Symbol für Zukunft, immer in westlicher Kleidung auf (u. a. S. 60–63, 144, 153), es sei denn, sie stehen für eine der vielen regionalen Kulturen Indiens (S. 157).

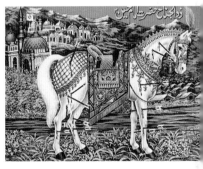

Die Aufgabe, bei aller Modernität kulturelle »Traditionen« aufrecht zu erhalten, fällt jedoch gemeinhin der »guten« indischen Frau zu; bei den zuversichtlichen Paaren auf den Etiketten von Feuerwerksraketen, die eine funkelnde Vision von Fortschritt und Entwicklung feiern (S. 64), trägt der Mann daher stets westliche Kleidung, sie dagegen einen Sari. In einem Land, dessen Bevölkerung technologischen Fortschritt zu einem großen Teil eher von Bildern als aus der Realität kennt, umgibt selbst scheinbar banale Gegenstände wie Fernseher und Radios oder Szenen aus dem Großstadtleben (S. 188) eine mythische Aura. Auf der Streichholzschachtel der Telefongesellschaft (S. 104) steht zum Beispiel die wohl bekannte Glückszahl 786, numerologisch abgeleitet von der ersten Zeile des Korans. Nirgends ist diese utopische Modernität so überdeutlich wie auf den Lehrtafeln, die ebenfalls in Sivakasi gedruckt und immer noch in Schulen im ganzen Land verwendet werden. Sie sind nicht nur Anleitungen für den »idealen Knaben« (S. 149), sondern für eine ideale Nation.

Heute muss man nicht mehr weit reisen, um indischen Ikonen zu begegnen: Nachdem die »globale« Kultur sie für sich entdeckt hat, tauchen Krishna und Kali, Duldul und Baba Deep Singh, der ideale Knabe und Chandrashekhar Azad auf CDs, Kalendern, Websites, Kleidung und Modeaccessoires von Delhi bis New York auf. Diese kulturellen Anleihen sind ein Reflex auf die unwiderstehliche visuelle Kraft der Bilder, ihre leuchtenden Farben, ihre kühne grafische Gestaltung und ihren komplexen Symbolismus. Doch während sie Eingang in neue Kontexte finden und sich in neuen Inkarnationen zeigen, bleibt zwangsläufig etwas auf der Strecke: die zahllosen ineinander verwobenen Geschichten darüber, wofür diese Bilder stehen, wer sie geschaffen hat sowie die vielfältige Weise, in der sie das Leben und den Alltag von Millionen mitbestimmt haben.

India Bazaar

par Kajri Jain

Dieux rayonnants aux joues roses, enfants perpétuellement radieux, tombeaux de saints musulmans, héros de l'indépendance auréolés de ferveur nationaliste, bayadères chastes et séduisantes, cygnes et singes, radios et clefs... Intenses, stylisées, baignant dans des couleurs luxuriantes et trônant au centre de la composition, ces images sont

omniprésentes en Inde – vendues dans de petits cadres pour quelques roupies, sous forme d'affiches pour quelques roupies de plus, comme habillage de simples boîtes d'allumettes, d'encens ou de feux d'artifice, sur les calendriers publicitaires offerts par les entreprises. Ces reproductions commerciales et ces « avatars » du marketing local, communément appelées *calendar art* ou *bazaar art*, constituent une sorte d'univers parallèle en marge de la publicité traditionnelle, des beaux-arts, de l'artisanat ou de l'art populaire (bien que ces secteurs s'entrecroisent toujours un peu). Les chromolithographies plus anciennes et les boîtes d'allumettes sont devenues des objets de collection, donnant ainsi naissance à un art appliqué « millésimé », tandis que bon nombre des autres images présentées ici, notamment les « images encadrées », sont toujours très répandues.

On croit souvent à tort que le *calendar art* est une forme essentiellement urbaine. Prospérant sur les faibles marges de profit qu'offre un vrai marché de masse, il concerne les villes et les villages, la rue et la maison, le public et le privé. Il brouille les frontières entre la politique, le commerce, la religion et l'esthétique. Ses icônes sacrées et profanes sont présentes dans les espaces publiques – sur les lieux de travail comme sur la scène politique – autant que dans la sphère domestique – de la cuisine à la salle de prière en passant par la chambre à coucher. Elles gesticulent au-dessus des tableaux de bord dans les bus et les taxis, veillent sur les bureaux ministériels, les écoles et les usines, se balancent dans les arbres dans les marchés à ciel ouvert, trônent sur les caisses des boutiques et animent la propagande politique et la publicité. Ceux qui n'ont pas accès aux calendriers, affiches ou images encadrées peuvent aussi découper les divinités représentées sur des emballages et les vénérer dans leur sanctuaire domestique.

La production en masse des images commerciales de divinités et autres sujets mythologiques ou séculiers commença au cours de la période coloniale (seconde moitié du XIXe siècle). Bon nombre de ces lithographies ou oléographies s'inspiraient de peintures d'artistes parmi les plus renommés de leur époque, tels que Raja Ravi Varma (1848–1906). Ces derniers étaient encouragés par les administrateurs britanniques et l'élite indienne à mettre à profit leur formation artistique occidentale pour revisiter la mythologie indienne. De fait, l'influence du naturalisme européen est souvent plus flagrante dans ces premières images que dans celles, plus tardives, qui tendent à revenir à une iconographie stylisée et à des poses formelles associées aux représentations sacrées utilisées dans les temples lors des cérémonies rituelles. C'est le cas, par exemple, de l'avatar Matsya (p. 27), première des dix incarnations du dieu hindou Vishnou venu sauver le

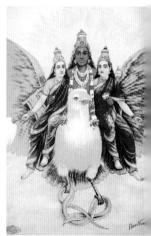

monde. Ici, il se métamorphose en poisson lors d'un grand déluge. Dans cette gravure ancienne, Vishnou est montré en train de sauver les quatre Védas (livres sacrés hindous) qui, par une métaphore inhabituelle, sont symbolisés par de joyeux nourrissons jouant dans une gestuelle naturaliste avec les ornements du dieu. Dans un autre exemple ancien, la pose alanguie du dieu à tête d'éléphant Ganesha, étendu au bord d'une rivière (p. 34), contraste nettement avec une image plus tardive (p. 35) qui le représente se tenant de manière plus formelle et plus figée sur un fond blanc, ses emblèmes étant soigneusement placés dans trois de ses quatre mains (un aiguillon à éléphant, un nœud coulant et un bol de friandises), sa dernière main faisant le geste de la bénédiction. La plupart des dieux hindous sont représentés avec leur *vahana* ou « animal-support » – un lion ou un tigre pour la puissante déesse mère prenant tantôt la forme de Kali, de Durga (dos de couverture), d'Amba ou de la Vaishno Devi (p. 26) ; une chèvre pour Meldi Mata, la déesse mère locale du Gujarat (p. 25) ; le taureau Nandin pour Shiva ; l'oiseau mythique Garuda pour Vishnou (p. 22) ; quant à Ganesha, non sans un certain humour, son « animal-support », qui apparaissent au premier plan des deux gravures, est une minuscule souris.

Certains des premiers éditeurs envoyaient les originaux en Allemagne et en Autriche pour les faire lithographier. Raja Ravi Varma, quant à lui, décida d'installer sa propre presse lithographique en 1894 près de Bombay (aujourd'hui Mumbay) avec l'aide d'un technicien allemand. Entre-temps, d'autres presses s'étaient également établies à Poona (Pune) et Kolkata (Calcutta). Comme on peut le constater ici dans les versions multiples de Krishna *Dérobant les vêtements des vachères* (pp. 29–30), le plagiat était (et demeure) monnaie courante. Ces presses approvisionnaient l'ensemble du pays en images encadrées et en affiches par l'intermédiaire de représentants itinérants œuvrant dans ce que les historiens ont appelé « l'économie de bazar », une série de réseaux informels dirigés par des communautés commerçantes indiennes qui assuraient le lien entre le commerce colonial d'une part et les producteurs et consommateurs indiens d'autre part. Même après que l'Inde eut obtenu son indépendance en 1947, l'économie de bazar perdura parallèlement à l'économie dirigé par l'État et au secteur privé, ce dernier étant largement contrôlé par une élite ayant reçu une éducation anglaise.

Les premières lithographies, qui desservaient un marché plus vaste que celui des images peintes, prirent rapidement un ton politique. Le langage visuel national auquel elles donnaient forme transcendait les nombreuses cultures régionales, unissant les Indiens contre le pouvoir colonial britannique en forgeant une langue commune aisément compréhensible par tous. Aux thèmes religieux et mythologiques s'ajoutèrent bientôt des icônes séculaires telles que le Mahatma Gandhi (p. 142) ou des révolutionnaires nationalistes tels que Chandrasekhar Azad (p. 151), Bhagat Singh (p. 159) et Subhash Chandra Bose (p. 152). (Les exemples présentés dans ce livre sont des reproductions plus récentes, encore vendues aujourd'hui.) D'autres images encore, telles que la *Vache avec quatre-vingt-quatre dieux* (pp. 44–45), éditée par Ravi Varma Press, traitaient des conflits interreligieux, souvent attisés par les administrateurs britanniques afin de diviser les mouvements anticoloniaux. Ici, la vache, créature sacrée pour les hindous, est représentée englobant quatre-vingt-quatre divinités et donnant son lait à toutes les communautés sans discrimination tandis que le monstre s'approchant pour la tuer incarne les mangeurs de viande (notamment les musulmans) contres lesquels il fallait la défendre.

Si les progrès technologiques de l'imprimerie permirent d'étendre le marché des images religieuses et mythologiques, ils n'en furent pas à l'origine. Le chemin avait déjà été tracé aux XVIIIe et XIXe siècles par les communautés d'artistes qui les peignaient à la main et les

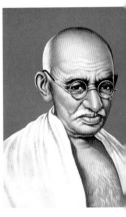

Above: Mahatma Gandhi; above left: Matchbox label; below left: Garuda Vahan Vishnu (Vishnu on His Vehicle, Garuda)

vendaient dans des centres de pèlerinage populaires. Ainsi, une branche de l'art de bazar (*bazaar art*), celle des images comme biens de consommation, remonte à l'époque où, libérées du pouvoir et du contrôle des prêtres, les images pieuses commencèrent à circuler sur les marchés. L'autre branche, celles des images religieuses servant à rehausser l'esthétique d'*autres* produits, fut une émanation du commerce colonial. En effet, les Britanniques ciblaient les Indiens comme consommateurs potentiels des produits de leur révolution industrielle, notamment ceux de leurs filatures. Les entreprises anglaises furent parmi les

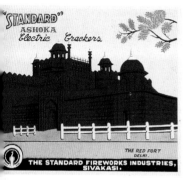

THE RED FORT
DELHI.
THE STANDARD FIREWORKS INDUSTRIES, SIVAKASI.

premières à utiliser l'iconographie hindoue sur les étiquettes de leurs tissus pour séduire les clients indiens. De même, les fabricants d'allumettes suédois et autrichiens utilisèrent les images mythologiques de Raja Ravi Varma sur les boîtes destinées au marché indien. Si les entreprises étrangères se fondaient sur une vision stéréotypée de la religiosité indienne, les exemples présentés ici montrent que les producteurs indiens de textiles et d'allumettes qui, au cours des premières décennies du XXᵉ siècle, imprimaient leurs propres étiquettes, recouraient à un registre de thèmes beaucoup plus étendu.

Le village de Sivakasi dans le sud de l'Inde fut l'un des premiers centres de production d'allumettes, son climat chaud et sec étant également propice à l'imprimerie et à la fabrication de feux d'artifice. Le succès phénoménal de ses activités lui valut la réputation de « mini Japon ». L'imprimerie y apparut en 1928 avec des étiquettes

lithographiées pour boîtes d'allumettes et de feux d'artifice, puis elle s'est étendue à l'emballage et à l'étiquetage d'autres produits locaux. Peu après l'indépendance, les presses de Sivakasi s'enrichirent de machines offset à haut rendement, souvent achetées d'occasion ou provenant d'Allemagne de l'Est qui, en raison des liens étroits qu'entretenait l'Inde avec les pays de l'Union soviétique, acceptaient les paiements en roupies. L'industrie graphique de Sivakasi, dirigée par son fondateur Nadar et sa communauté entrepreneuriale, pouvait produire à bas prix grâce à la convergence de facteurs favorables : salaires relativement bas, personnel qualifié, combinaison ingénieuse de méthodes faisant appel à une abondante main d'œuvre et à la mécanisation – tels que l'association de la peinture et de la photographie pour produire des œuvres d'art et des négatifs –, sans oublier un système décentralisé de services auxiliaires permettant de limiter les frais généraux. L'organisation du secteur des calendriers préfigurait les formes actuelles du capitalisme décentralisé, échappant ainsi à l'étape d'urbanisation propre à l'histoire du monde occidental moderne. Vers le milieu des années 60, l'imprimerie en couleur de Sivakasi avait optimisé ses coûts de production au point qu'elle pouvait concurrencer les presses des principales métropoles. En 1980, cette petite agglomération pouvait se targuer d'accueillir 40 pour cent des capacités d'impression offset de tout le pays. Là encore, en dépit de sa situation géographique à l'extrême sud du sous-continent, son réseau de revendeurs dans les bazars lui permit d'assurer la distribution extensive et intensive de ses produits tant sur le territoire national qu'au-delà de ses frontières.

Il n'y a donc rien d'étonnant à ce que presque toutes les images de ce livre, à l'exception des chromolithographies plus anciennes, aient été imprimées à Sivakasi. Les boîtes d'allumettes des années 30 à 60 portent la marque des procédés lithographiques, avec d'épais contours

FIRE-FLY BASKET

noirs, des aplats de couleur et des mouchetures ombrées. Les images offset plus récentes se distinguent par des couleurs saturées, brillantes, des contrastes appuyés et de puissants rehauts. Ces effets sont obtenus principalement par d'importantes retouches à la main lors de la séparation des couleurs dans la phase de pré-presse, puis par la superposition de plaques rouges et bleues lors de l'impression. D'abord utilisés pour pallier des problèmes techniques, ces caractères sont devenus partie intégrante de l'esthétique Sivakasi, au point que les imprimeurs qui recourent aujourd'hui au scannage et à la séparation informatisés utilisent souvent des logiciels pour obtenir des résultats similaires.

Ces manipulations ne sont pas vraiment du goût des auteurs des images originales. Comme le fait remarquer un vieux maître du *calender art*, Yogendra Rastogi de Meerut : «[...] même s'il s'agit du dieu Ram, ils ont trouvé le moyen de lui mettre un rouge à lèvres à la manière de l'actrice Saira Bano ! ». Plusieurs illustrateurs de calendriers ont été formés dans les écoles d'art fondées par les Anglais. C'est le cas notamment d'Indra Sharma (né vers 1925) ; issu de la communauté de peintres de la ville sainte de Nathdwara, il a étudié dans les années cinquante à la prestigieuse école d'art de Bombay connue sous l'abréviation « J. J. » d'après le nom de son fondateur, Sir Jamsetjee Jeejeebhoy, et partage à présent son temps entre Bombay, Nathdwara et les États-Unis où vit sa fille. Les artistes de Nathdwara approvisionnent l'industrie du calendrier et des images encadrées depuis les années vingt (voir, par exemple, *Virat Swaroop* de M. K. Sharma, p. 23) tout en cultivant la tradition des peintures murales que l'on peut admirer dans les temples ou des miniatures vendues aux pèlerins. Venkatesh Sapar (né en 1967) est sans doute l'un des illustrateurs de calendriers les plus prolifiques et polyvalents de notre époque. Tout comme sont épouse et assistante Maya, il a fait ses études à « J. J. » avant de revenir s'installer dans la province de Sholapur pour reprendre l'atelier de peinture sur calendrier fondé par son père et son oncle.

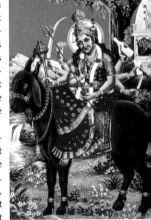

Ces images populaires sont donc souvent réalisées par des artistes formés selon une tradition dérivée de l'art occidental qui, parce qu'elle est présente en Inde depuis plus d'un siècle, doit être considérée comme une tradition indienne au même titre que leurs autres sources d'inspiration. Cela signifie, entre autres, que ces artistes souffrent du fait que leur art, dépendant du marché, est souvent considéré comme une forme d'art « kitsch », dégradé, vulgaire et commercial. Toutefois, même si elles jouent consciemment avec plusieurs traditions, leurs créations recourent rarement à l'ironie ou à l'autodérision – ce qui est parfois le cas quand elles sont reprises par des stylistes sur des t-shirts ou des sacs à main. Les artistes de calendriers prennent les diktats du marché de l'iconographie religieuse très au sérieux, car leur survie en dépend.

Si chacune de ces images porte l'empreinte de son créateur – les éditeurs établissent une distinction entre les « vrais » artistes et les « tâcherons » –, le système de valeurs du marché des calendriers ne privilégie pas particulièrement la créativité des individus (comme dans le cas des beaux-arts). Le plus souvent, on n'achète pas un calendrier pour son auteur mais pour son thème (de fait, la plupart des gens auraient bien du mal à nommer un seul illustrateur de calendriers, mis à part Ravi Varma). De ce point de vue, les caractéristiques formelles des images iconiques de Sivakasi doivent être comprises non pas tant en fonction de leur originalité artistique mais selon d'autres critères de valeur et de puissance, notamment leur capacité à remplir de grâce ceux qui les contemplent et à leur porter chance. En vertu de la croyance selon laquelle il est aussi important d'être vu par l'icône que de la voir, les divinités des calendriers regardent ceux qui les regardent depuis le centre de l'image. Leur tête est légèrement plus grosse que la normale proportionnellement au reste du corps

et leurs yeux, d'où est censée émaner la grâce divine, sont fortement accentués. Plusieurs dieux présentés dans ce livre lèvent la main droite dans un geste de bénédiction (Vaishno Devi, p. 26 ; Meldi Mata, p. 25 ; Santoshi Mata, p. 180 ; Shiva et Parvati en couverture). La bienveillance qu'expriment les icônes envers leurs dévots est de la plus grande importance. Le naturalisme de la technique se concentre donc dans le regard de la divinité et ses expressions faciales. On ne cherche pas à obtenir une perspective réaliste dans l'ensemble de la composition, les tailles et les positionnements étant déterminés par l'importance relative des personnages ou de la séquence narrative.

Prenons par exemple l'image de rituel hindou du *karva-chauth*, où les femmes prient Ganesha de veiller sur le bien-être de leurs maris (p. 47). Ici, la figure la plus grande est celle

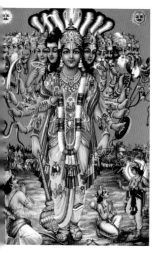

de Lakshmi, déesse de la prospérité, mais on lui a superposé un cercle central montrant Shiva, Parvati et leurs fils Ganesha et Kartikeya qui, dans ce contexte, revêtent autant d'importance que Lakshmi, sinon davantage. Les figures périphériques, plus petites, sont celles des dévots et des personnages du mythe du *karva-chauth*. En revanche, la scène de *Virat Swaroop* (p. 23) montre un personnage central à la fois important et physiquement gigantesque, car il s'agit de la représentation d'un épisode du *Mahabharata* ou « grande guerre », où Krishna se révèle sous sa forme omnipotente dans laquelle l'univers tout entier devient visible. Ici, il est montré avec tous les dieux enchâssés dans son corps. Le petit personnage agenouillé devant lui est le guerrier Arjuna. En plus petit, à droite, on voit les même deux personnages juste avant la révélation, au moment où Krishna récite à Arjuna son célèbre sermon connu sous le nom de *Bhagavad Gita* afin de l'aider à surmonter ses scrupules à l'idée de partir en guerre contre ses propres cousins.

Cependant, ces images ne représentent pas que des icônes bienveillantes et des divinités anthropomorphiques. Les affiches où figurent les « *karni-bharni* » ou « actes et châtiments » (p. 158) adressent de sévères mises en garde illustrées à ceux tentés par l'adultère, la tricherie, la corruption, l'avarice, le vol ou le surmenage imposé à leurs bêtes de somme. On trouve une image de la déesse mère destructrice Kali, piétinant accidentellement son époux Shiva endormi dans un accès de rage aveugle (p. 31). Une autre image illustre la célébration du martyr du saint guerrier sikh Baba Deep Singh, qui se révolta en 1757 contre l'occupation d'Amritsar dans le Pendjab par l'Afghan Ahmad Shah (p. 49). Avant la bataille, il avait juré de ne pas mourir avant d'avoir atteint le Harminder Sahib (le Temple d'or des Sikhs). La légende veut que, même après avoir été décapité, il tint sa tête dans ses mains et continua de se battre jusqu'aux portes du temple, après quoi il la fit rouler sur les derniers mètres jusqu'à l'entrée. Les reproductions de ce mythe devinrent particulièrement prisées après 1984, quand l'armée indienne lança l'assaut contre le Temple d'or dans une tentative du premier ministre de l'époque, Indira Gandhi, d'asseoir l'autorité du gouvernement central sur les militants sikhs qui réclamaient leur indépendance. (Le temple leur servait de refuge et de cache d'armes. Six à sept cents militants et quatre-vingt soldats furent tués pendant l'attaque et Indira Gandhi fut assassinée quatre mois plus tard.) Une autre scène de martyr, dans la tradition islamique cette fois, montre le campement de

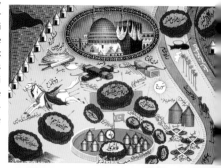

Kerbala en Iraq où Hussein, petit-fils du prophète Mahomet, fut tué pour avoir refusé de reconnaître le calife Yazid (pp. 54–55). Compte tenu de l'interdiction par l'islam des représentations iconographiques, aucun personnage saint n'apparaît dans cette scène, seule la fidèle monture d'Hussein, Duldul, y figure. Toutefois, les représentations humaines ne sont pas totalement proscrites dans les images islamiques d'Asie du Sud (voir pp. 52 et 53).

La plupart des images musulmanes ne doivent pas leur intensité visuelle à la description d'une émotion positive ou négative, mais à l'utilisation de la couleur, à la calligraphie ornementale (p. 59) et à l'élément symbolique de la lumière (noor) qui rejaillit sous forme de rayons, d'étincelles, rehauts ou de pierres précieuses étincelantes (p. 56). Dans cette veine islamique, les images de lieux saints et de pèlerinage sont particulièrement caractéristiques : la Mecque, Médine, Ajmer Sharif ou Haji Malang près de Mumbay (p. 58) qui apparaît ici sur une sorte de cartes du pèlerin montrant les étapes de son voyage, les sites importants et les différents modes de transport disponibles pour s'y rendre. Ce tombeau d'un saint musulman est sacré pour les hindous, les musulmans, les chrétiens et les parsis (zoroastriens). Pendant des générations, il a été gardé par une famille brahmane. On citait souvent Haji Malang comme le symbole de la coexistence et de la fusion des traditions syncrétiques de l'Inde... jusqu'à ce que des nationalistes hindous tentent de le récupérer comme lieu saint hindou en 1996.

Outre les divinités, les lieux de pèlerinage et les symboles religieux, le registre visuel des auspices favorables intègre également des emblèmes profanes tels que les héros nationalistes, les épouses fidèles et les enfants respirant la santé. On peut y déceler également les signes de modernité et de progrès, souvent assimilés à une forme d'occidentalisation. On remarquera que les enfants, symboles de l'avenir, sont presque toujours vêtus à l'occidentale (pp. 60–63, 144, 153, etc.), sauf lorsqu'ils incarnent les diverses cultures régionales (p. 157). Toutefois, c'est à la « bonne épouse » indienne qu'il incombe le plus souvent de préserver les « traditions culturelles » de la modernité. Par conséquent, lorsqu'un couple radieux est représenté sur un emballage de feux d'artifice célébrant une vision éclatante du progrès et du développement (p. 64), l'homme porte une tenue occidentale et son épouse, un sari. Dans un pays où, pour de nombreuses personnes, la technologie moderne est plus un concept qu'une réalité, les objets en apparence anodins tels que les télévisions et les radios, ou les scènes de la vie urbaine (p. 188), sont auréolés d'une aura mythique. Une boîte d'allumettes Telephone, par exemple, affiche le chiffre porte-bonheur 786, dérivé par numérologie du premier verset du coran (p. 104). Cette modernité utopique revêt une connotation particulièrement émouvante dans les tableaux éducatifs, également imprimés à Sivakasi et encore utilisés dans toutes les écoles du pays. On y trouve des prescriptions non seulement pour « le garçon idéal » (p. 149), mais également pour la nation idéale.

Aujourd'hui, inutile de voyager loin pour trouver ces icônes indiennes : adoptés par la culture « planétaire », Krishna, Kali, Duldul, Baba Deep Singh, le garçon idéal et Chandrasekhar Azad figurent sur les pochettes de CD, les agendas, les sites Internet, les vêtements et les accessoires de mode de New Delhi à New York. Ces appropriations répondent à l'irrésistible pouvoir visuel de ces images, de leurs couleurs vives, de leur graphisme énergique, de leur symbolisme riche et complexe. Toutefois, à mesure qu'elles évoluent dans ces nouveaux contextes en revêtant de nouvelles incarnations, elles laissent inévitablement derrière elles quelque chose de plus profond : les innombrables histoires entrelacées qu'elles représentent, ceux qui les ont créées et les multiples avatars au travers desquels elles ont habité et animé des millions de vies quotidiennes.

Above: Educational chart; *above left: Virat Swaroop (Universal Form); below left:* Siege at Karbala

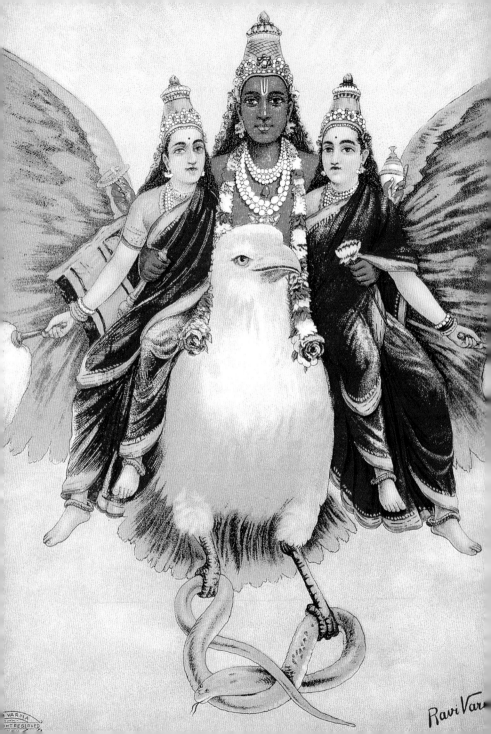

Ravi Var

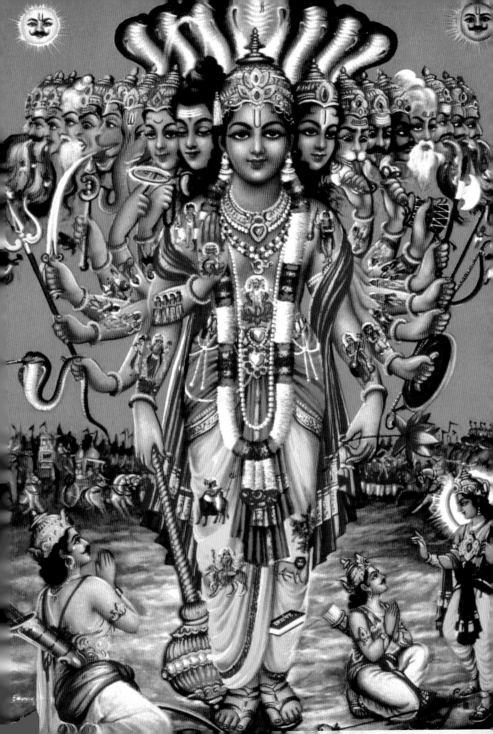

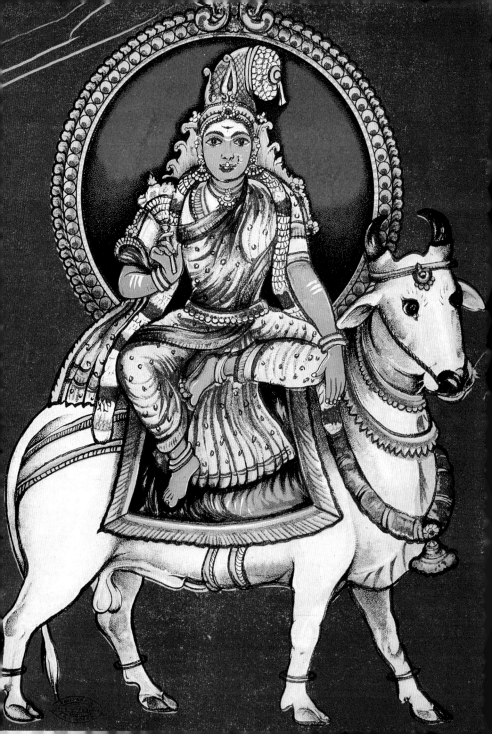

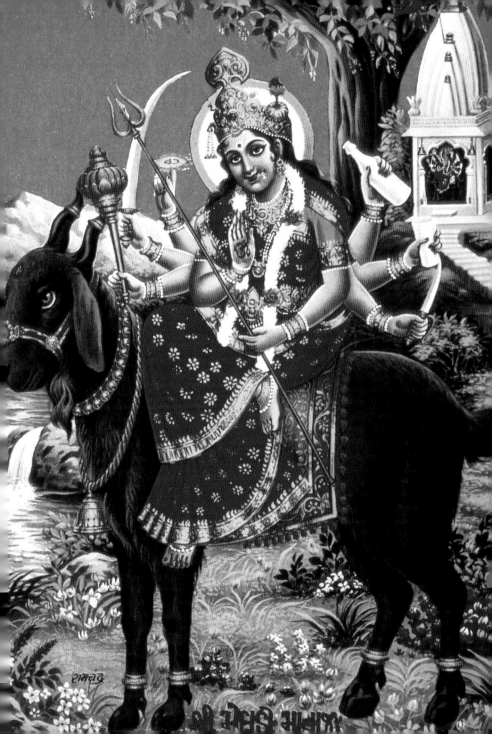

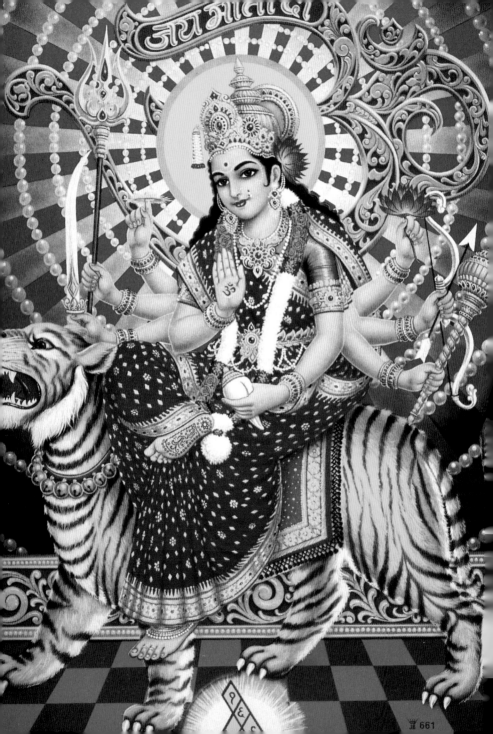

जय माता दी

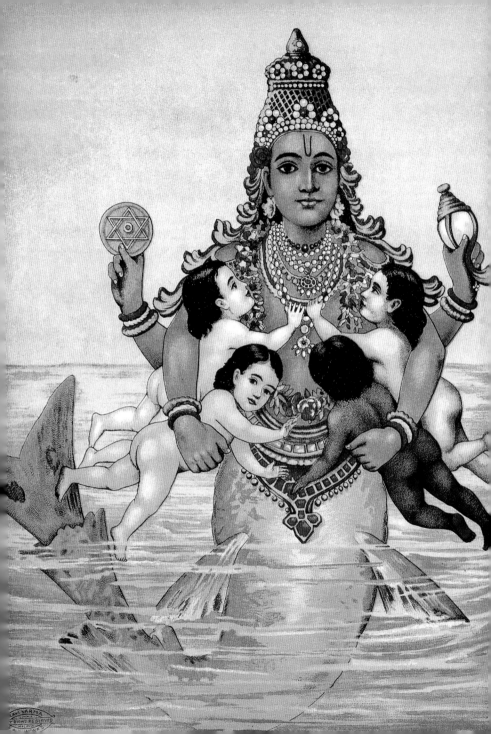

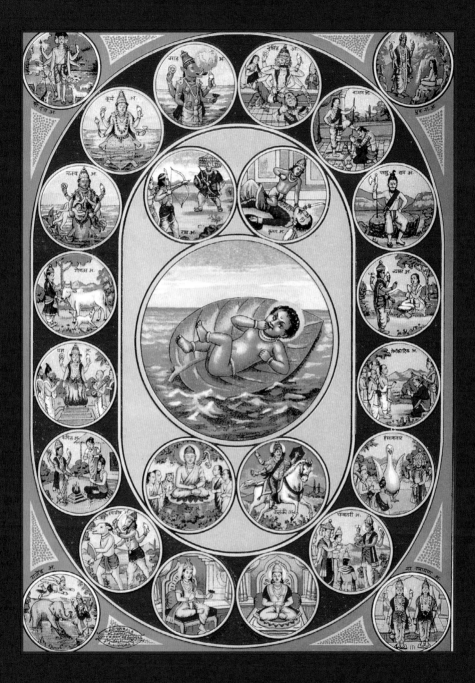

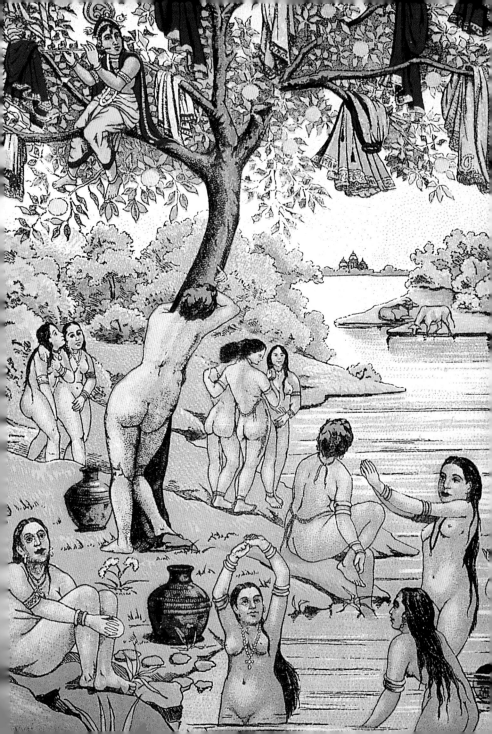

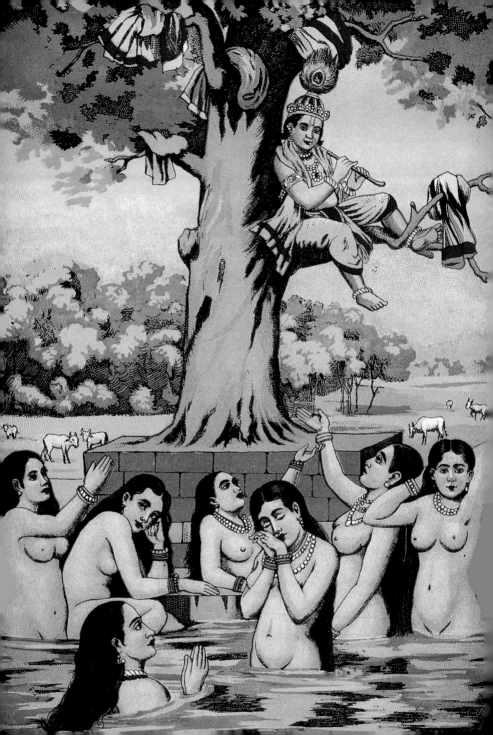

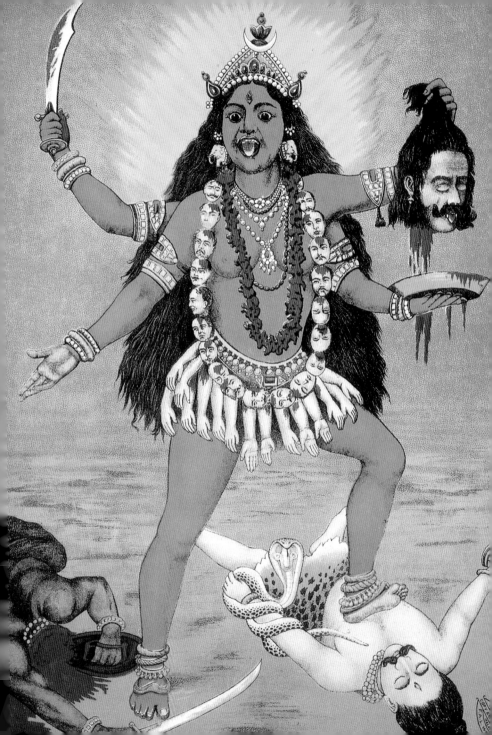

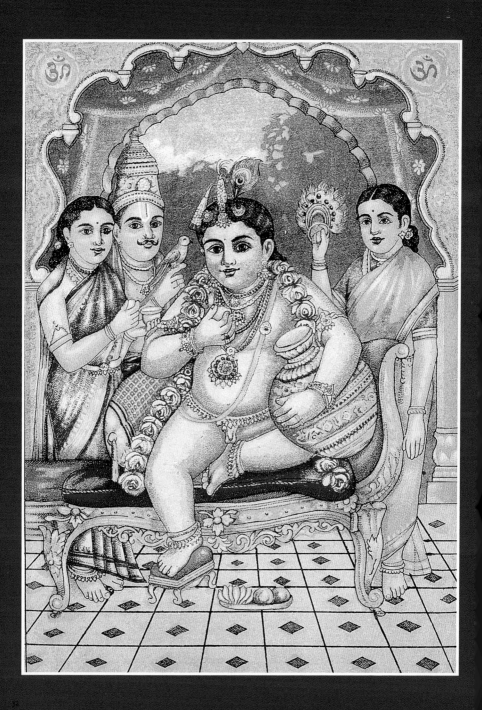

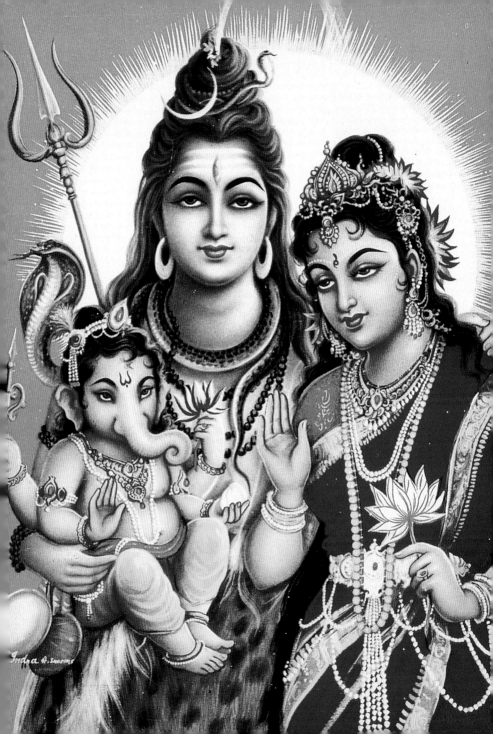

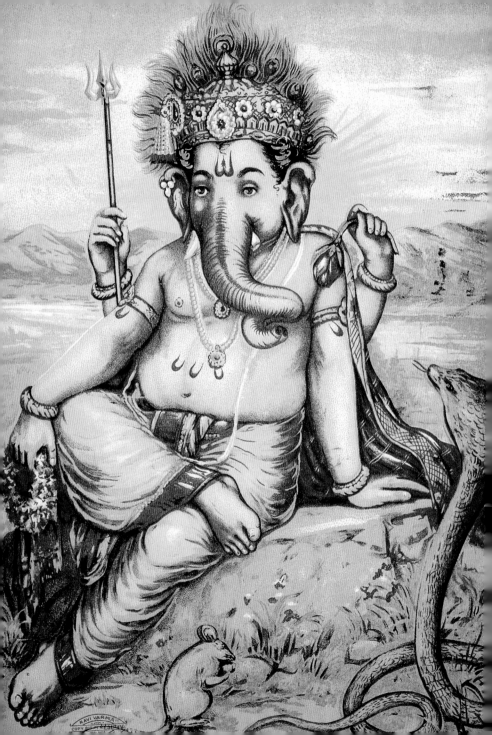

RAVI VARMA
COPY RIGHT RESERVED

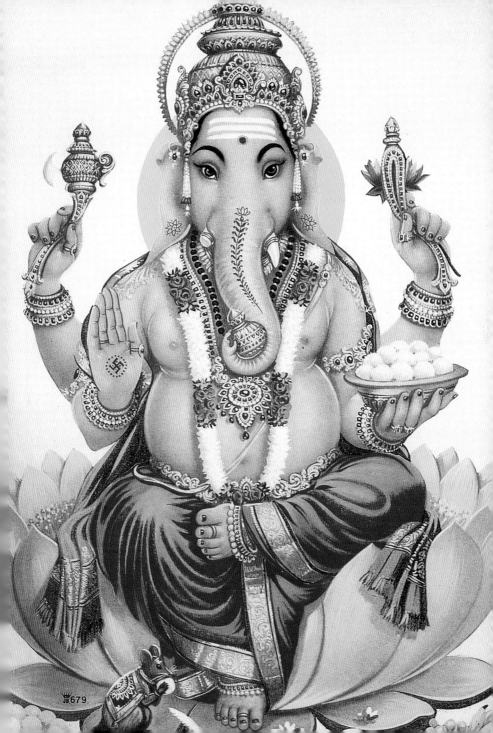

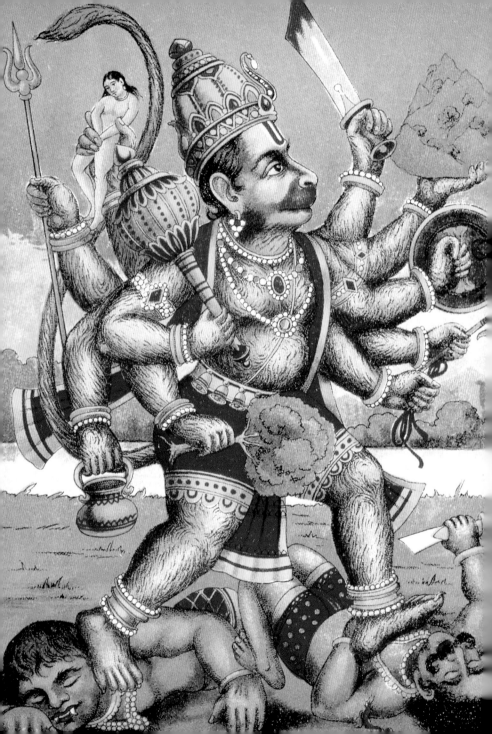

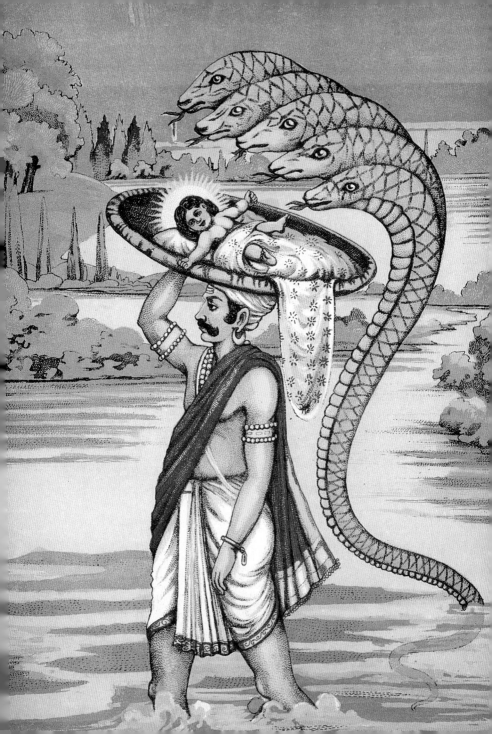

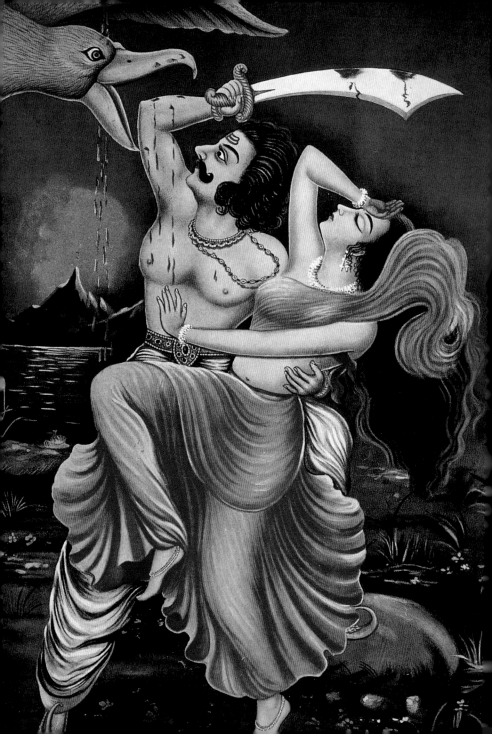

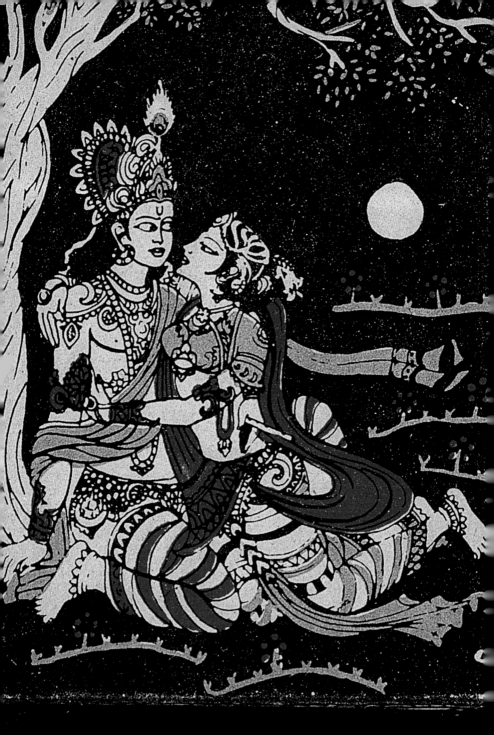

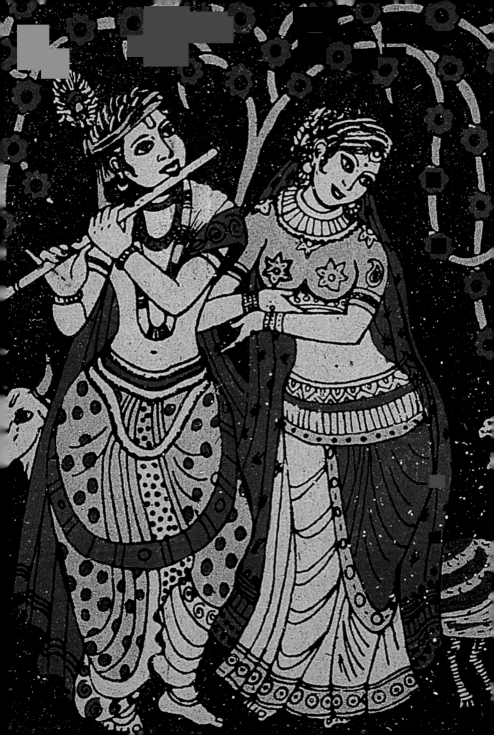

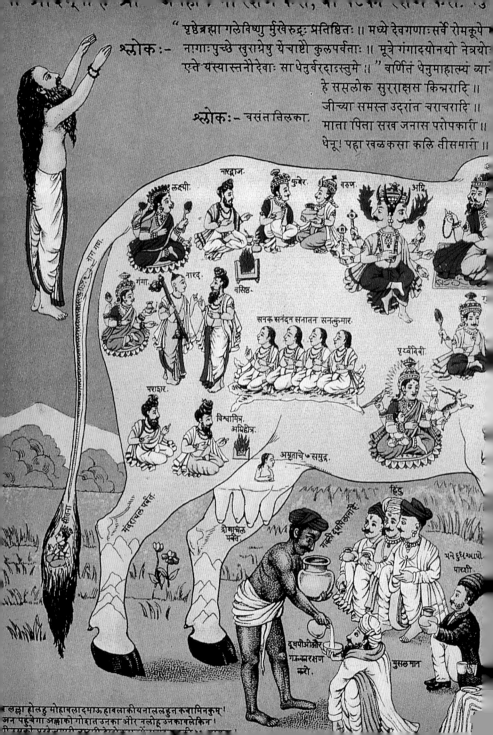

श्लोक:- "पृष्ठे ब्रह्मा गलेविष्णु मुर्खेरुद्रः प्रतिष्ठितः ॥ मध्ये देवगणाःसर्वे रोमकूपे
नागाःपुच्छे खुरायेषु येचाष्टौ कुलपर्वताः ॥ मूत्रे गंगादयोनघ्रो नेत्रयो
एते यस्यास्तनौदेवाः सा धेनुर्वरदास्तुमे ॥" वर्णित धेनुमाहात्म्य ंव्या
हे ससलोक सुरराक्षस किन्नरादि ॥
जीच्या समस्त उद्रांत चराचरादि ।
श्लोक:- वसंततिलका. माता पिता सरव जनास परोपकारी ॥
धेनू! पहा खवळकसा कलि तीसमारी ॥

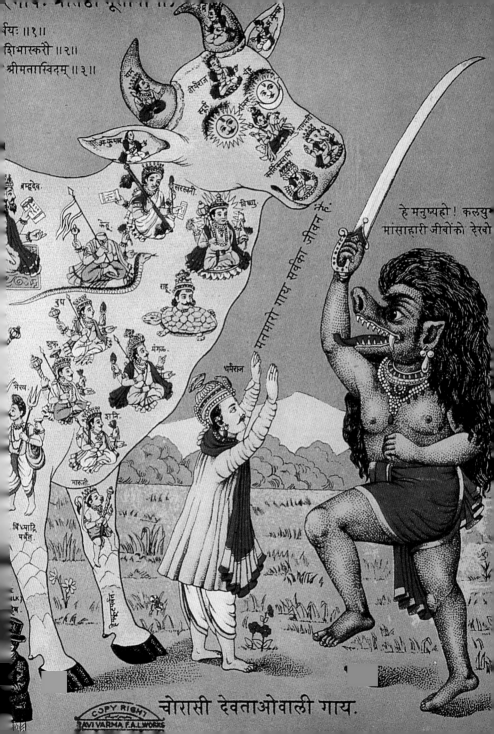

चौरासी देवताओंवाली गाय.

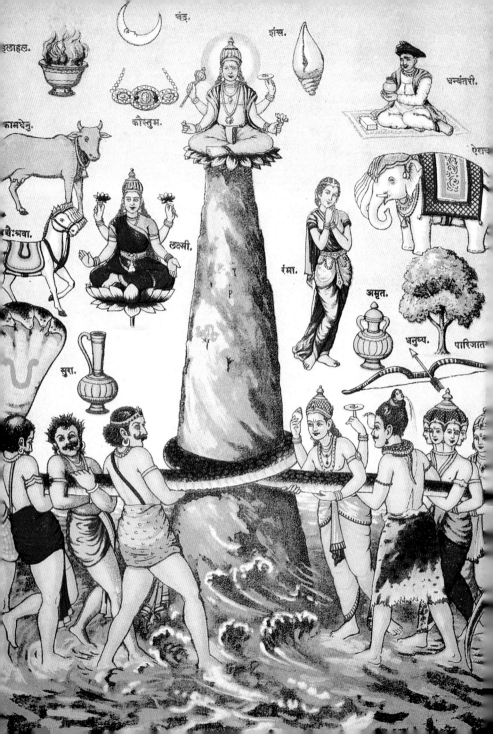

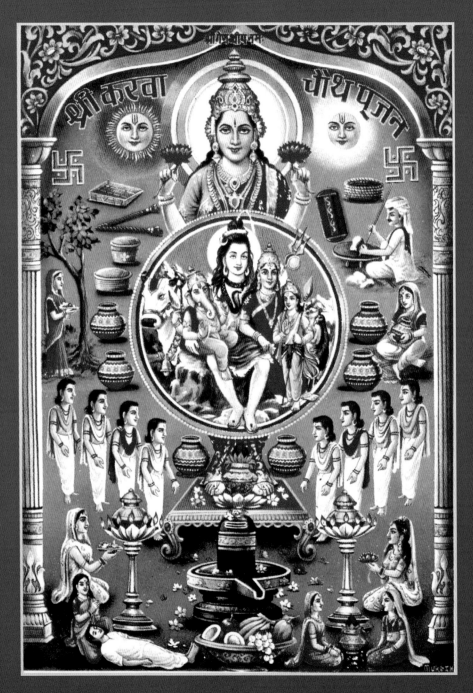

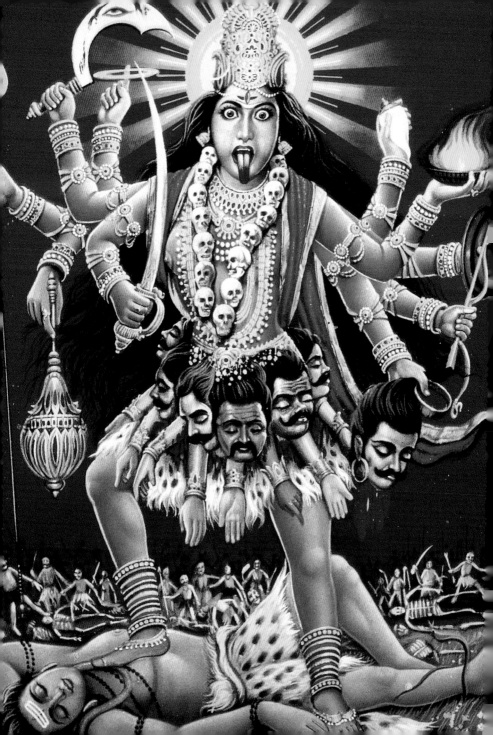

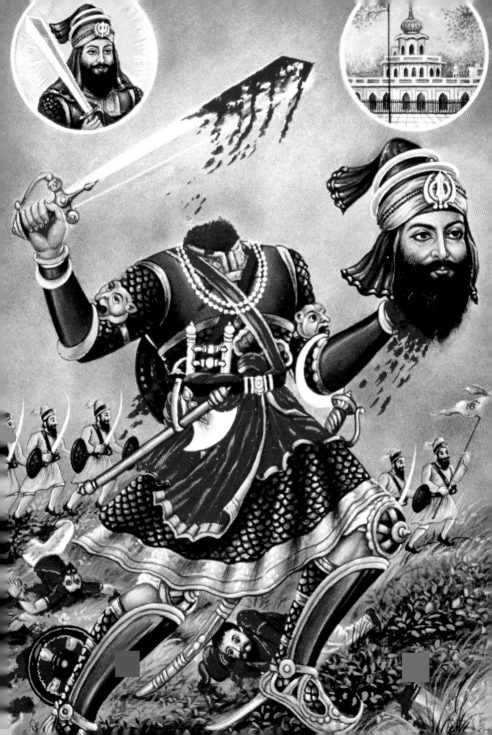

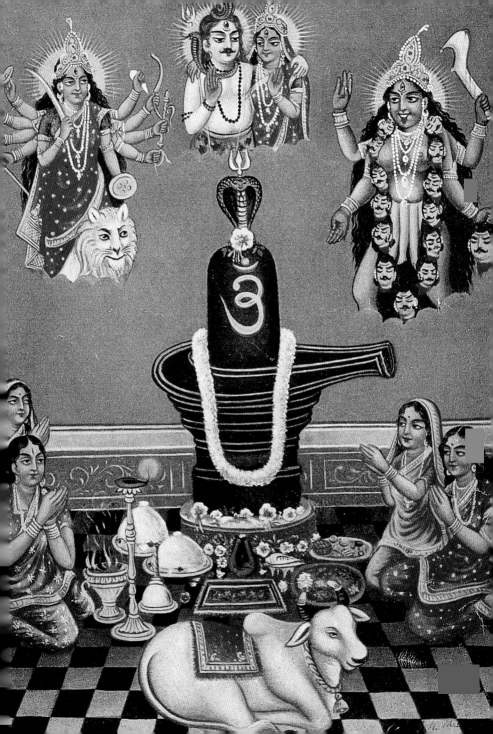

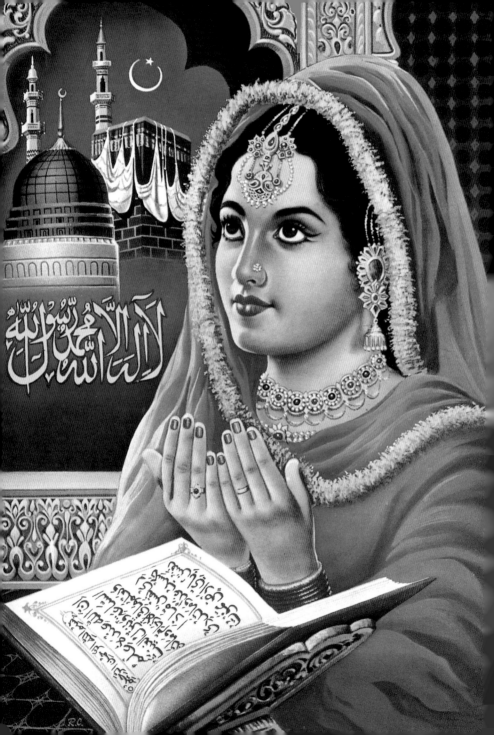

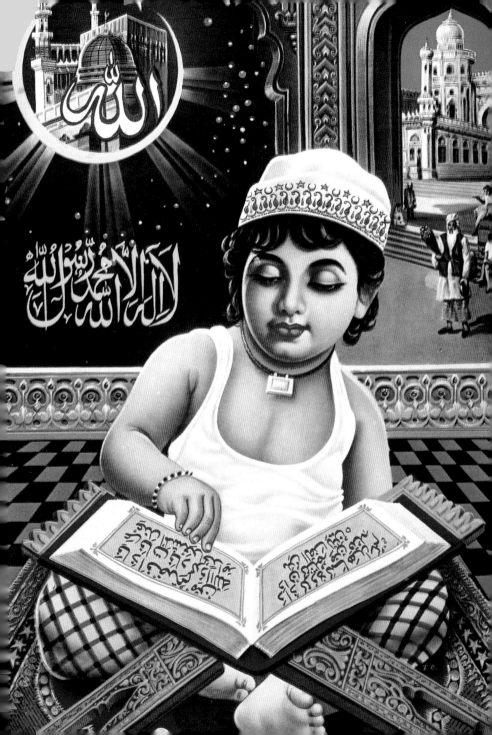

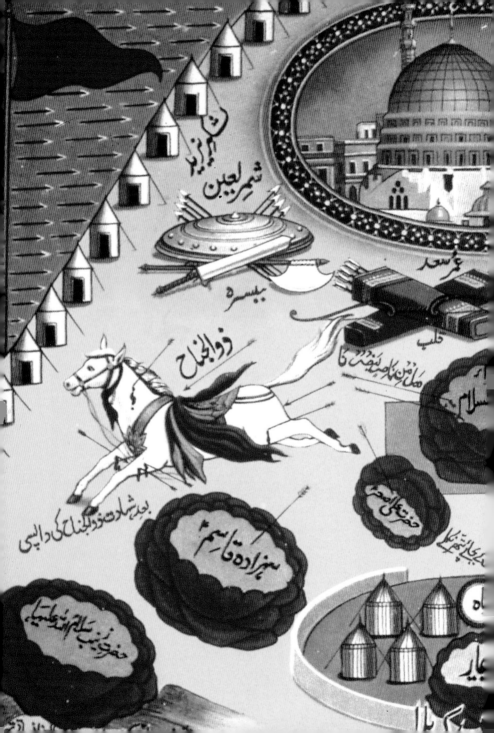

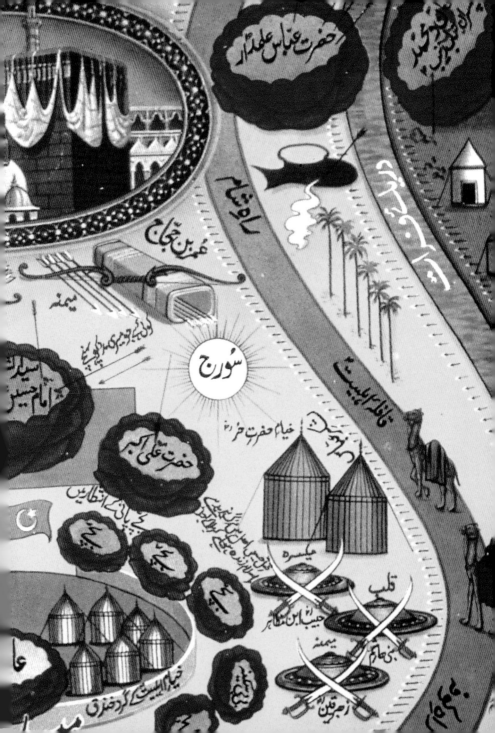

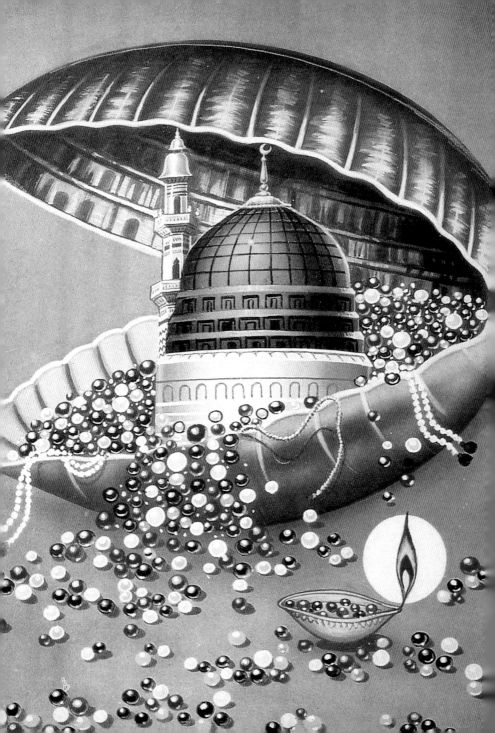

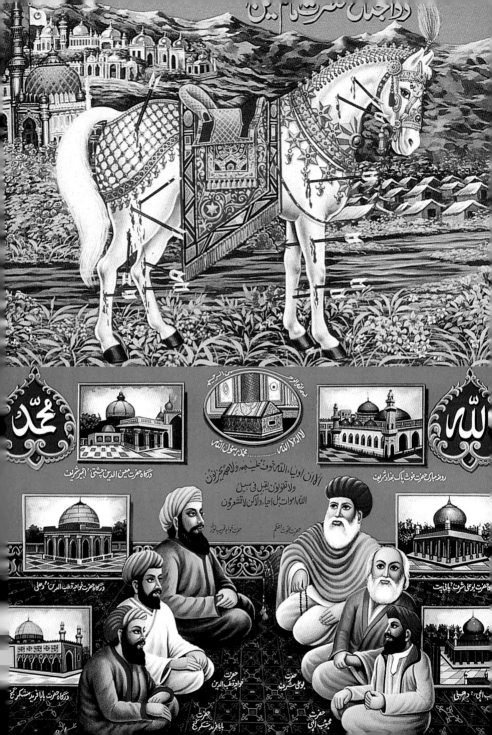

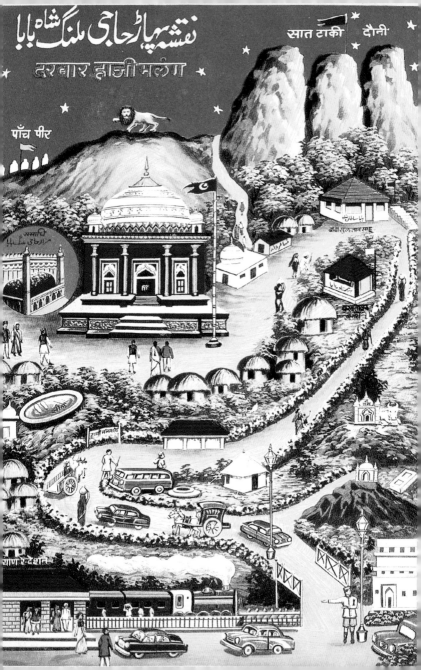

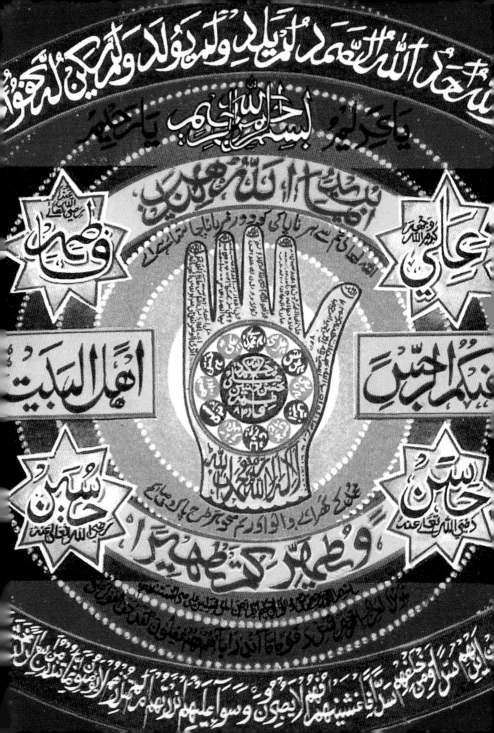

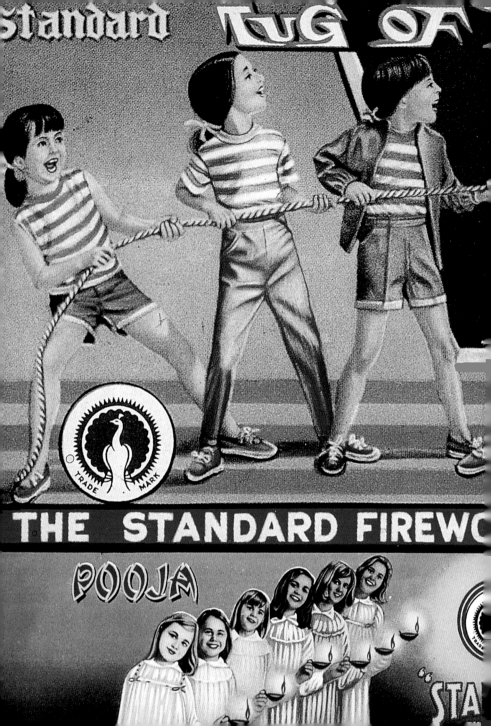

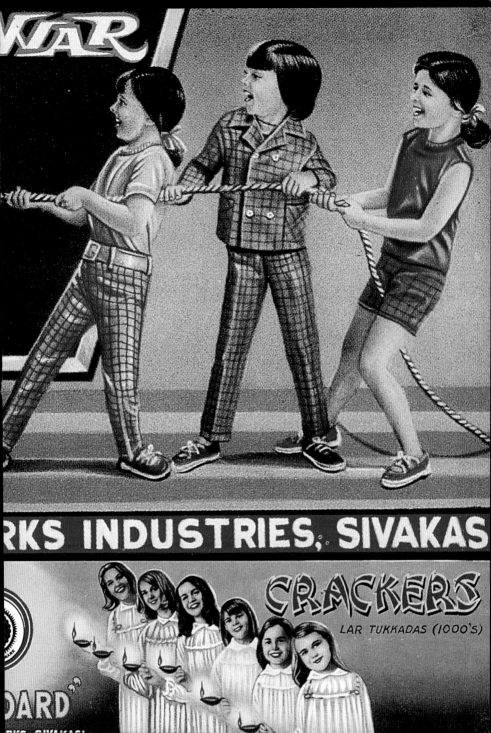

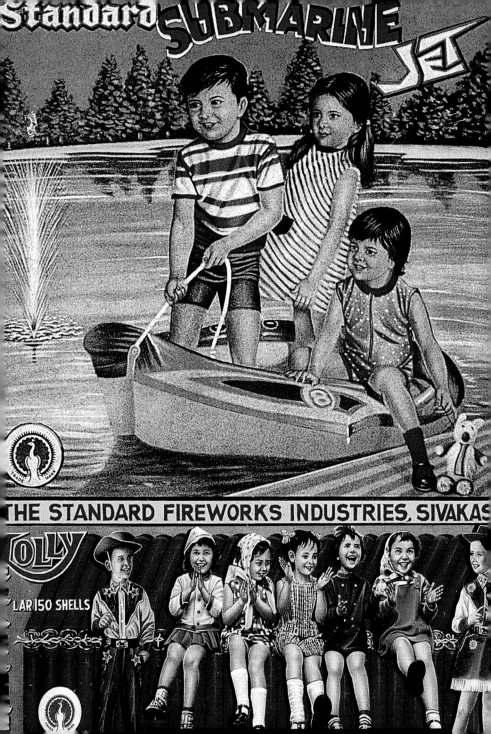

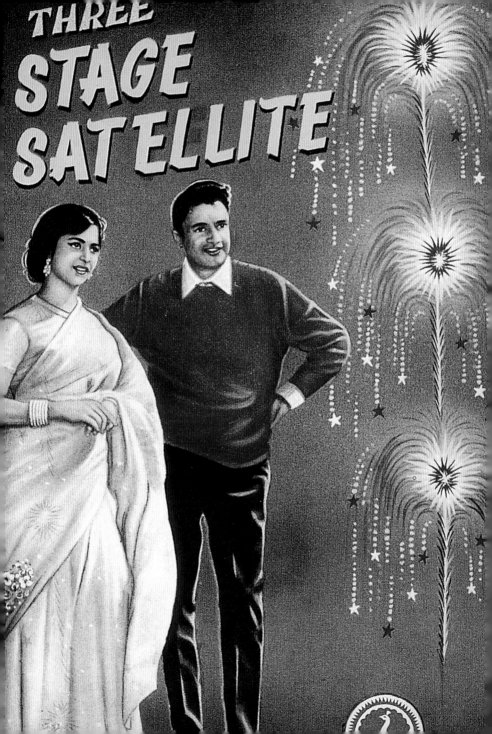

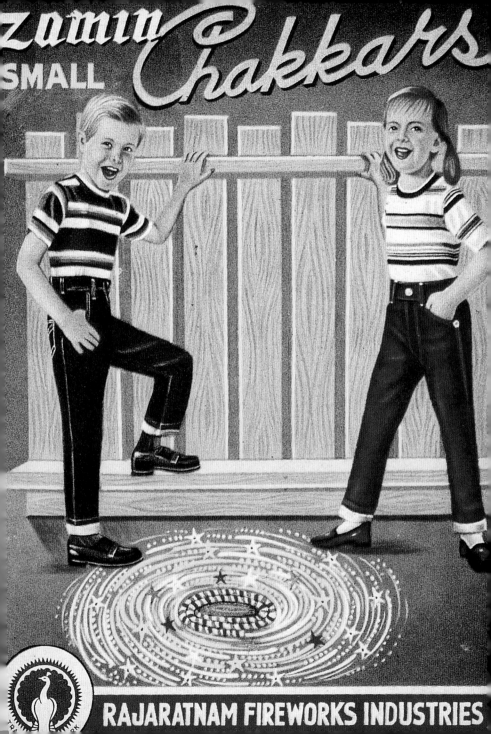

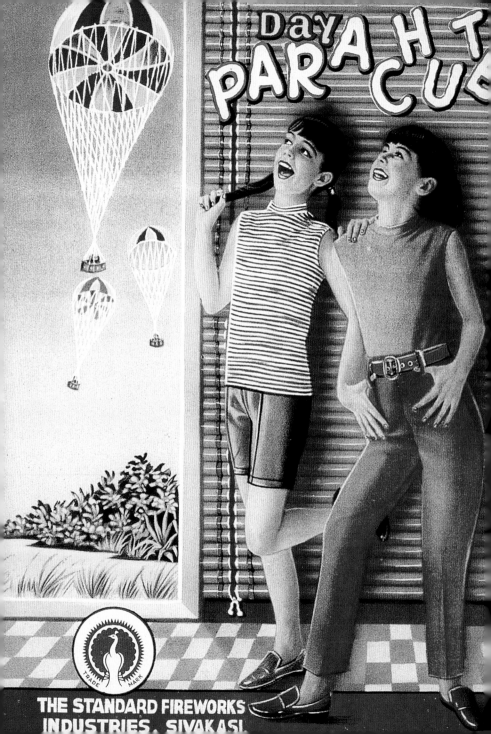

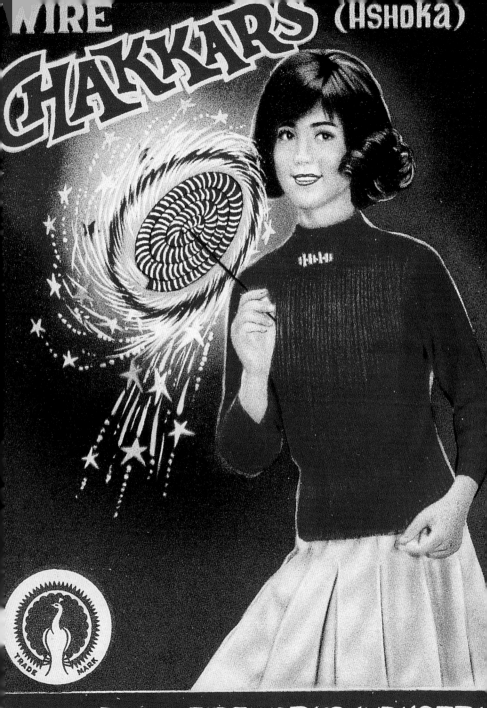

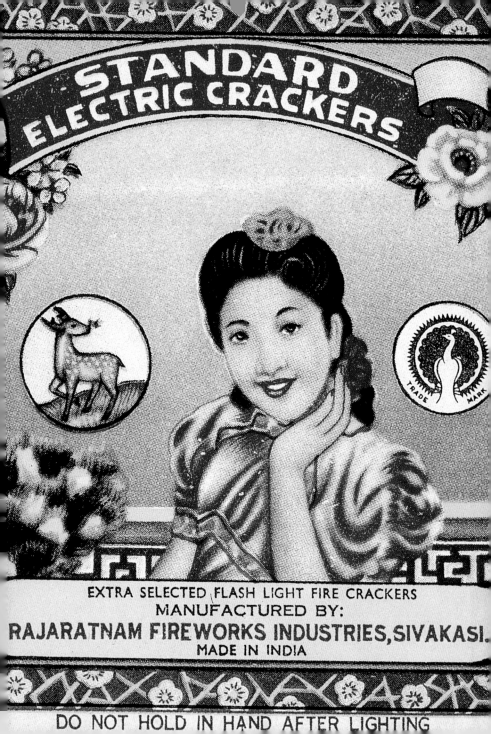

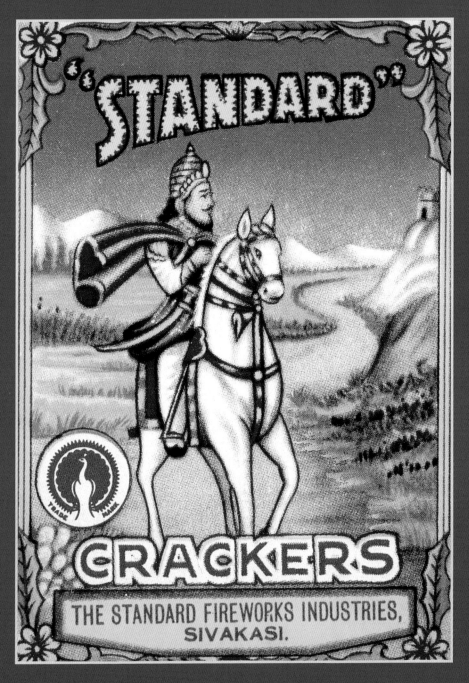

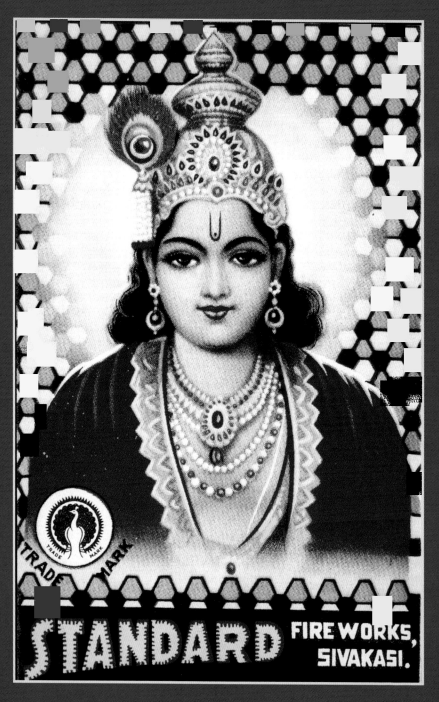

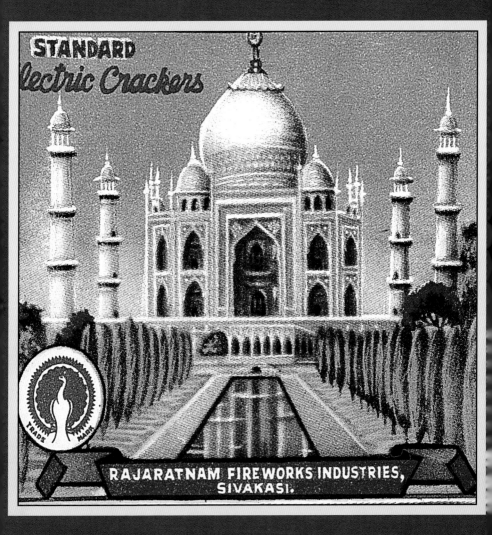

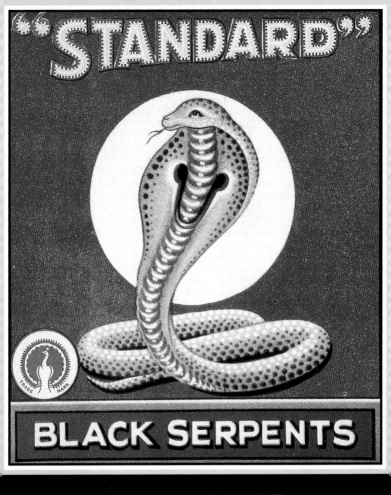

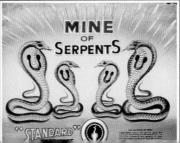

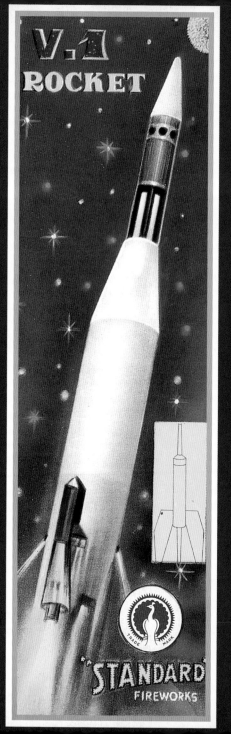

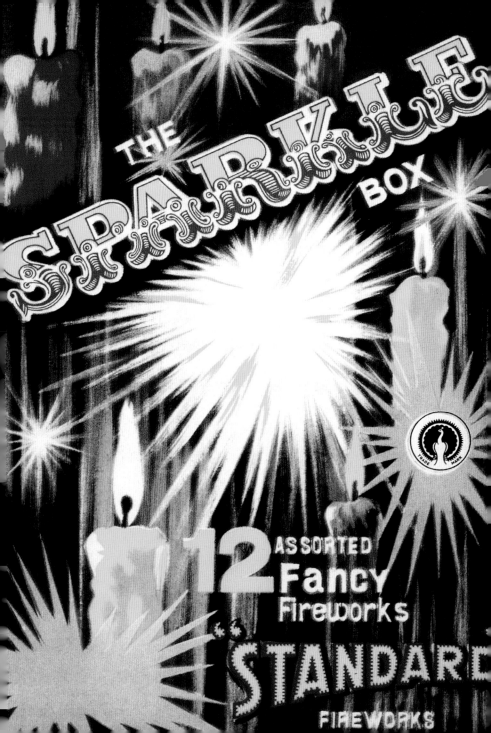

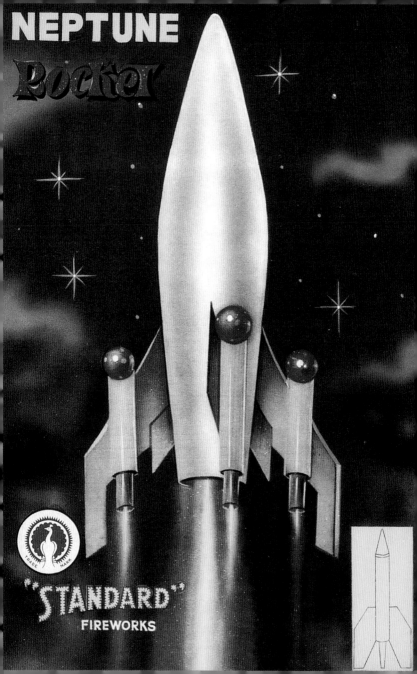

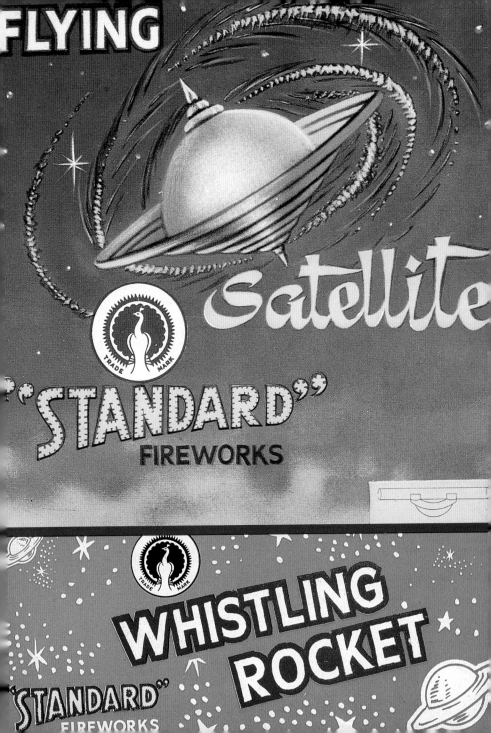

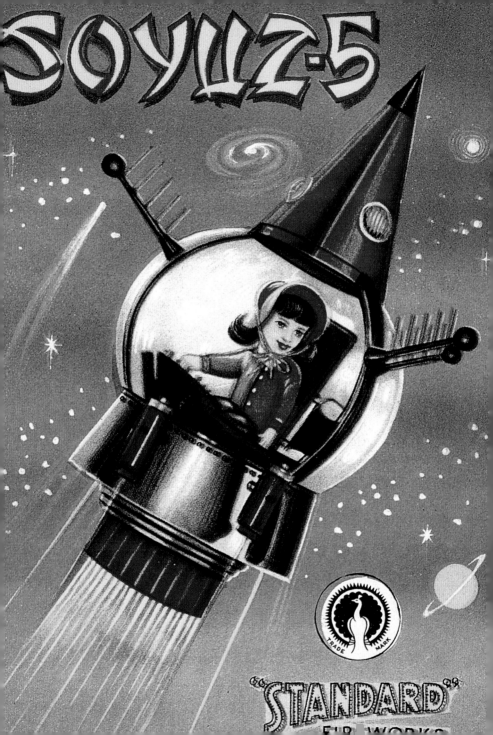

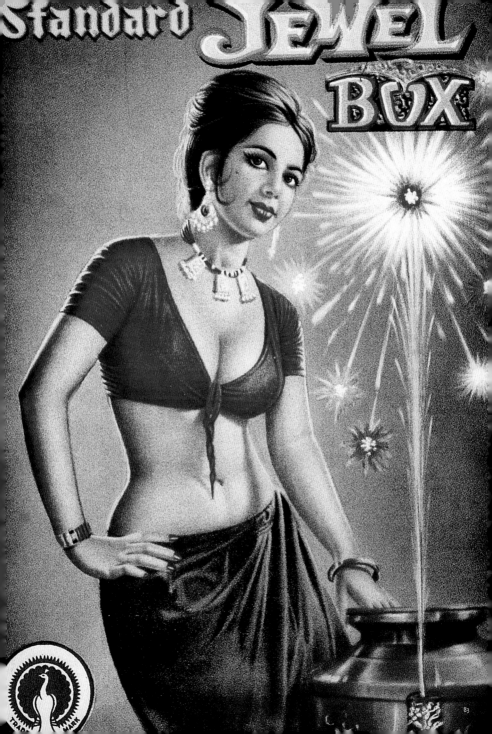

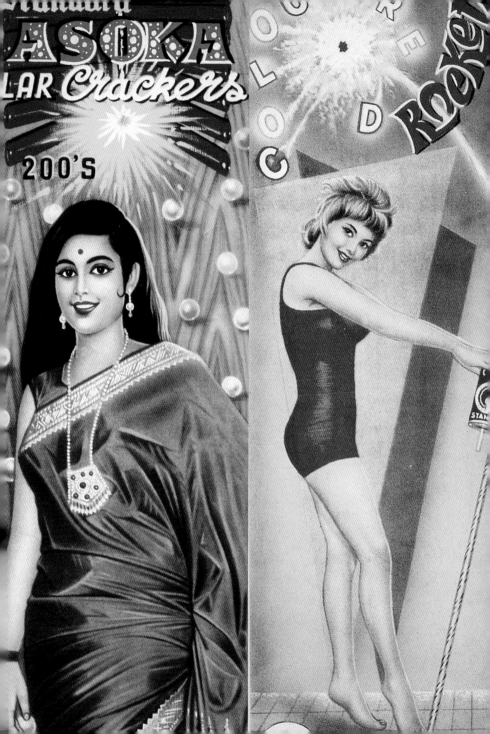

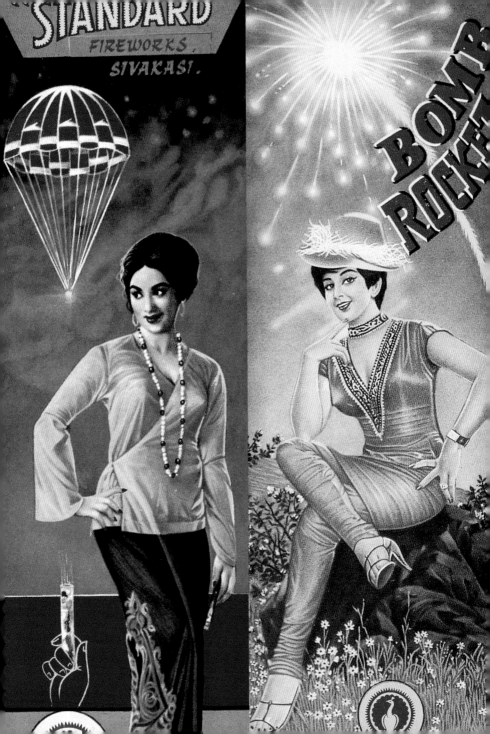

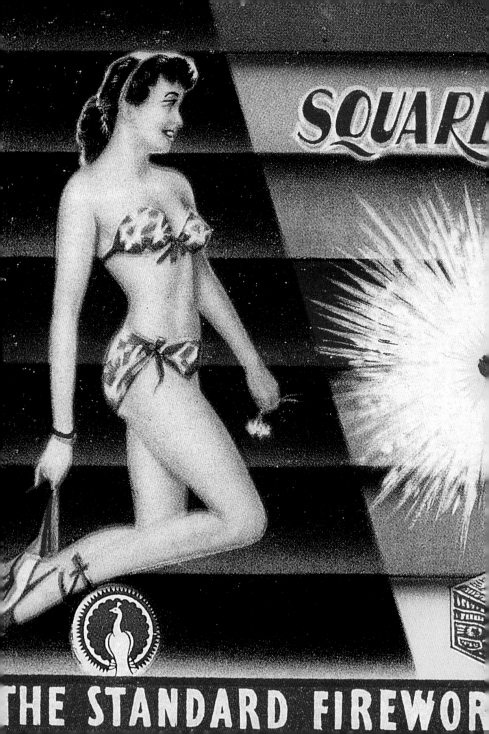

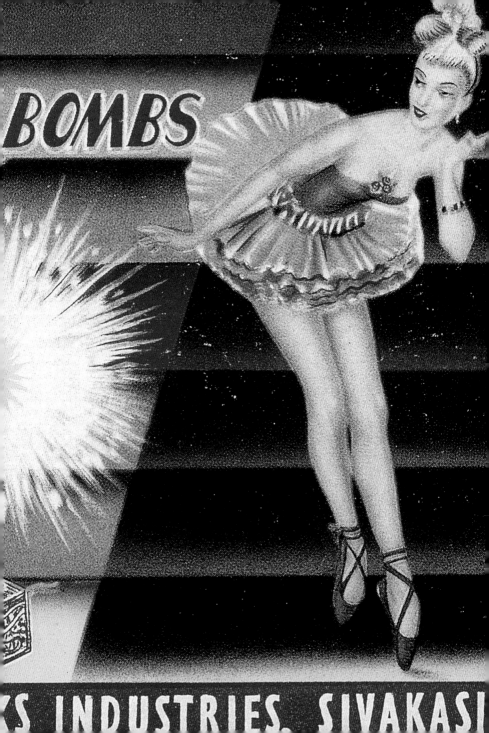

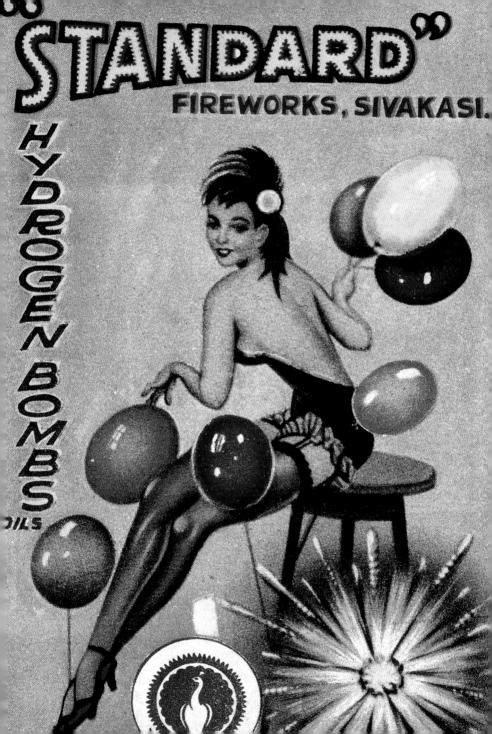

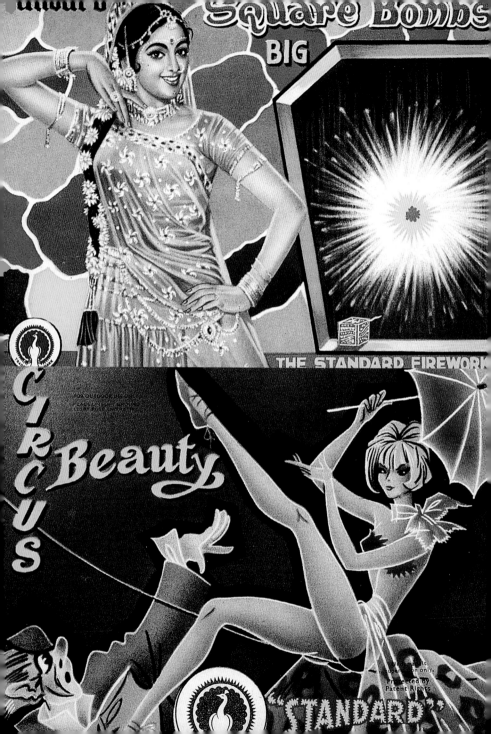

TRIPLE GUN

"STANDARD"
FIREWORKS

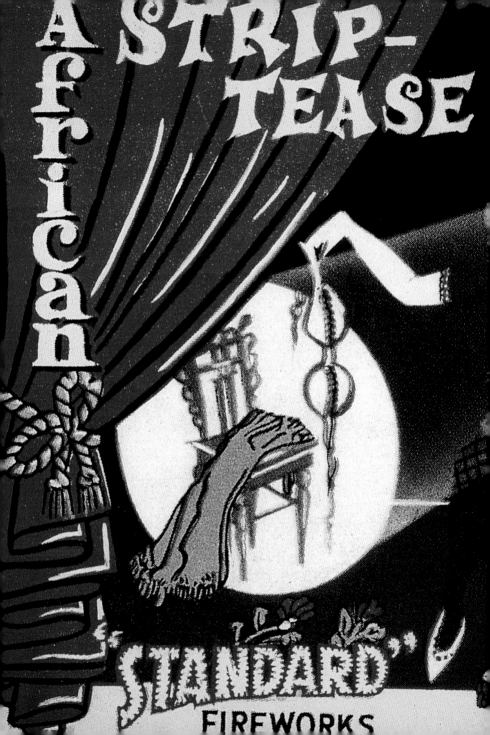

Under adult
supervision only

Protected by
Patent Rights

OUTDOOR USE ONLY.

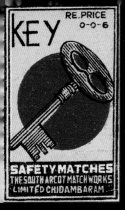

KEY
RE. PRICE
0-0-6
SAFETY MATCHES
THE SOUTH ARCOT MATCH WORKS
LIMITED CHIDAMBARAM

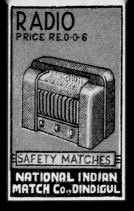

RADIO
PRICE RE. 0-0-6
SAFETY MATCHES
NATIONAL INDIAN
MATCH Co., DINDIGUL

SRIANDAL
PRICE RE. 0-0-6
SAFETY MATCHES
SELVARAJ MATCH WORKS
SRIVILLIPUTTUR.

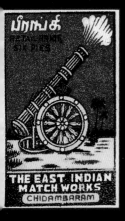

பிராங்கி
RETAIL RATE
SIX PIES
THE EAST INDIAN
MATCH WORKS
CHIDAMBARAM

கத்தி
KERALA MATCH FACTORY
POHANI
PRICE RE. 0-0-6
SAFETY MATCHES

SAILOR
PRICE Re 0-0-6
SIMCO
SOUTHERN INDIA MATCHES
NANABHAI JAMNADAS MEVAWALA
SURAT.

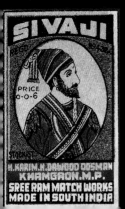

SIVAJI
REGD.
PRICE
0-0-6
STOCKIST
H. KARIM. H. DAWOOD OOSMAN
KHAMGAON. M.P.
SREE RAM MATCH WORKS
MADE IN SOUTH INDIA

FREE INDIA
SAFETY MATCHES
SARASVATHI MATCH FACTORY
KOVILPATTI

TYRE
PRICE
RE. 0-05
டயர்
SAFETY MATCHES
JAYAKAR MATCH WORKS
SRIVILLIPUTTUR

LAKSHMI
SAFETY MATCHES
60'S
PRICE.0-06
RAYAL SEEEMA
MATCH WORKS
CHITTOOR.

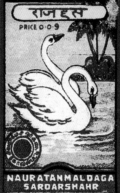

राजहंस
PRICE 0-0-9
NAURATANMALDAGA
SARDARSHAHR

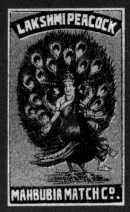

LAKSHMI PEACOCK
MAHBUBIA MATCH CO.

SPIDER
PRICE Rs0-0-6
SAFETY MATCHES
NAVA INDIA MATCH WORKS
THAYILPATTY.

STANDARD
JAI HIND
SAFETY
MATCHES
CALCUTTA
MYSORE
SMILE
MADE IN MYSORE

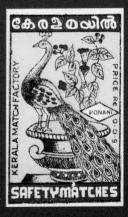

കേരളമയിൽ
KERALA MATCH FACTORY
PRICE Re 0-0-9
PONANI
SAFETY MATCHES

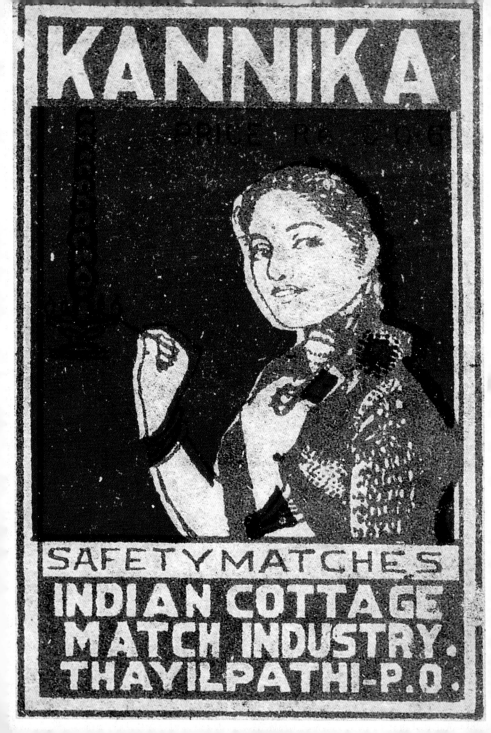

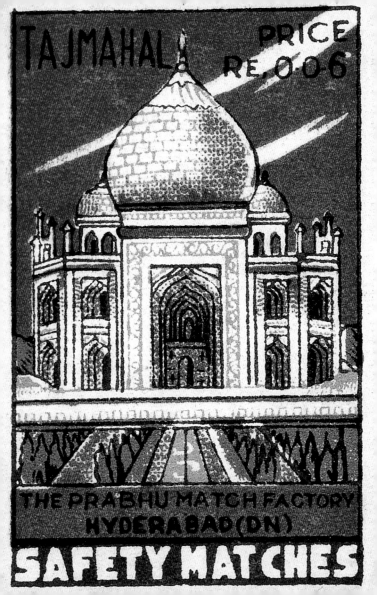

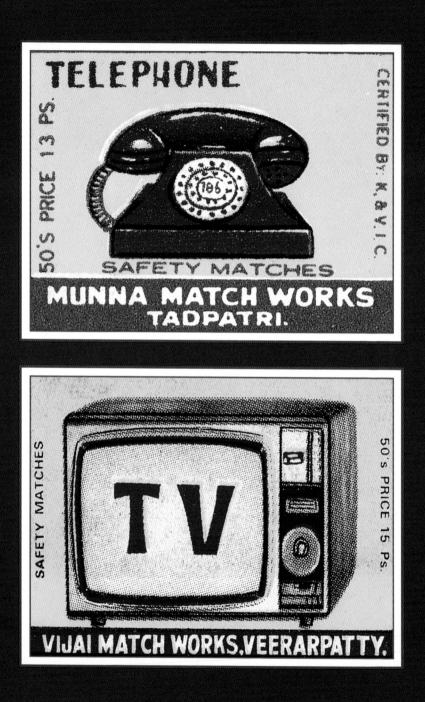

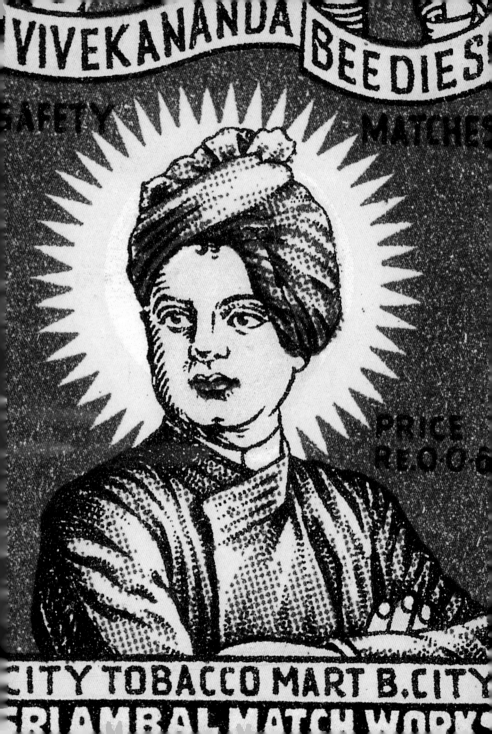

STAR MATCHES

KASTHURI MATCH INDUSTRIES SIVAKASI

PRICE RE. 0-0-9 दीपक

NAURATAN MAL DAGA, SARDARSHAHR

LAILA MAJNU

PRICE RE, 0-0-6

J. B. SANTDAS & CO. BAJWADA, BARODA.

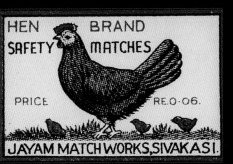

HEN BRAND SAFETY MATCHES

PRICE RE.0-06.

JAYAM MATCH WORKS, SIVAKASI.

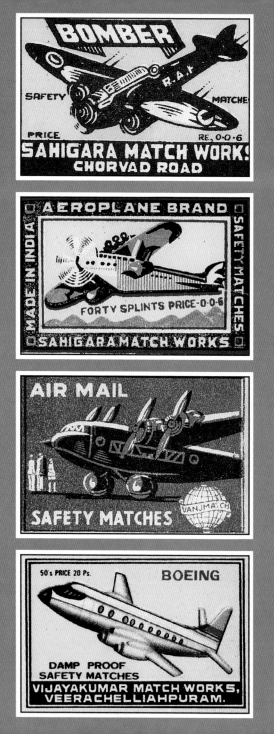

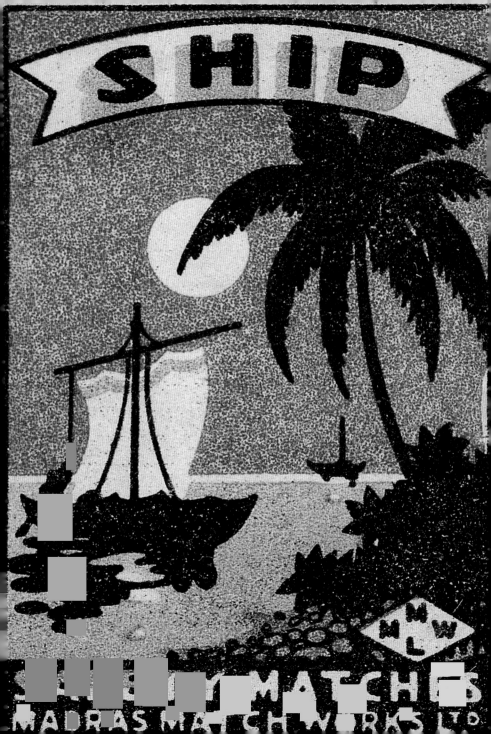

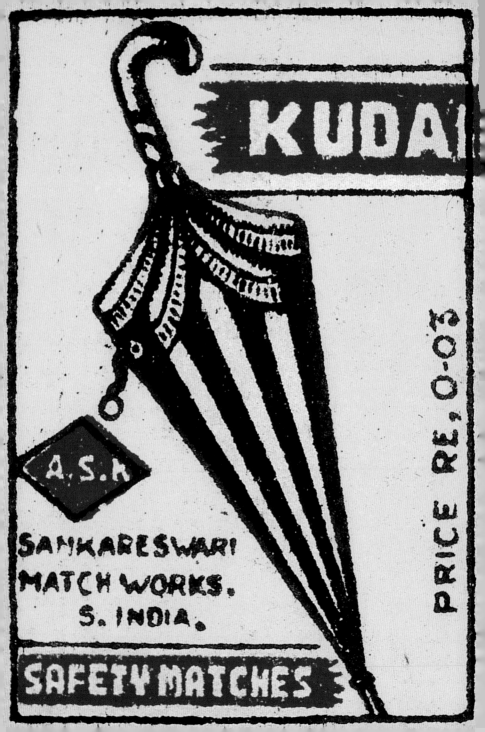

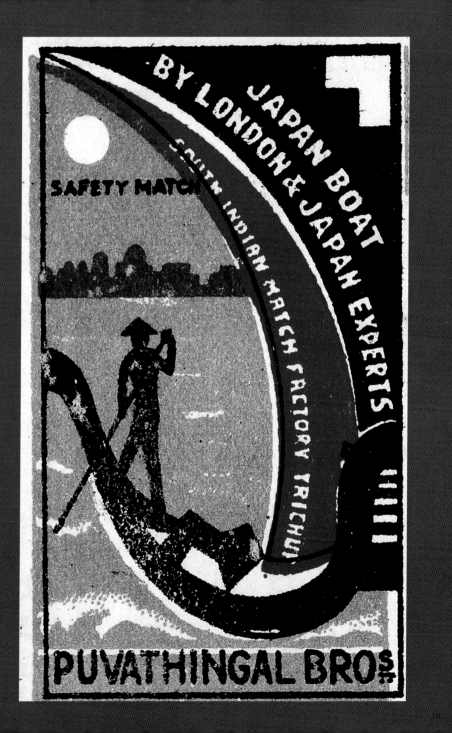

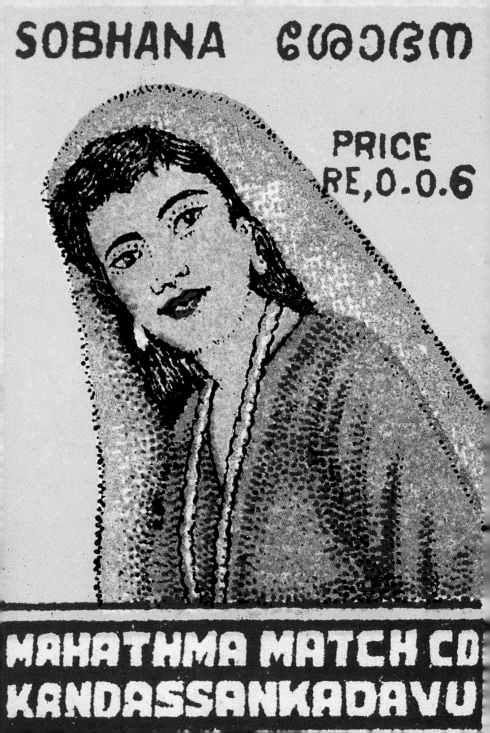

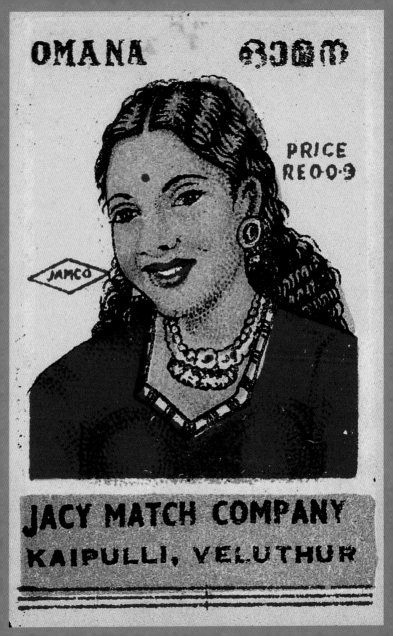

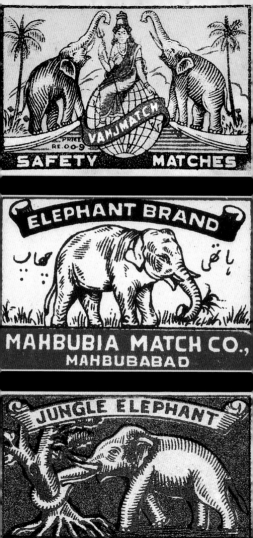

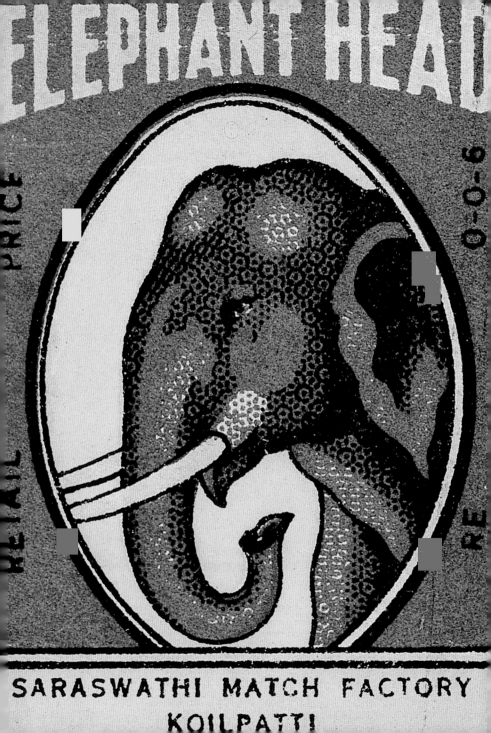

CAMEL HEAD

PRICE
Re. 0-04

ராஜமணிமேச்பாக்டரி.
சாத்கார்.

HASHMATRAI & SONS BOMBAY
& NAGPUR.

SHIKAR

RENGAR MATCH COMPANY, TURAIYUR.

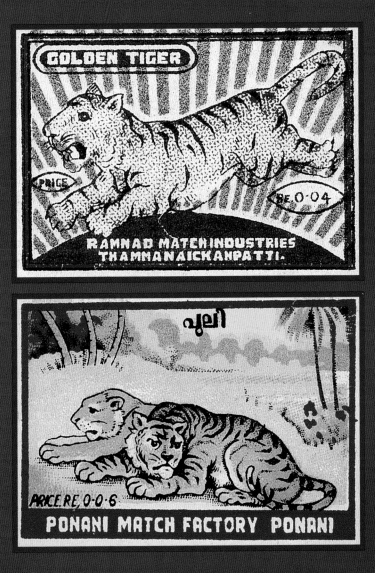

MOTHI

SAFETY MATCHES

MAHESWAR MATCH INDUSTRIE
TADPATRI.

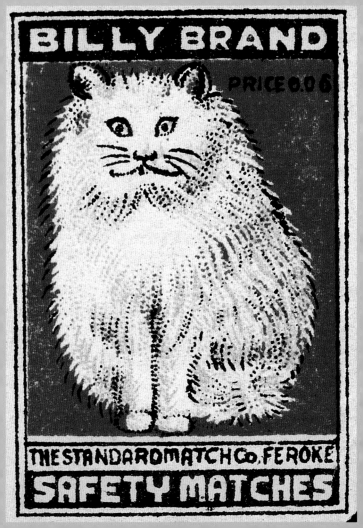

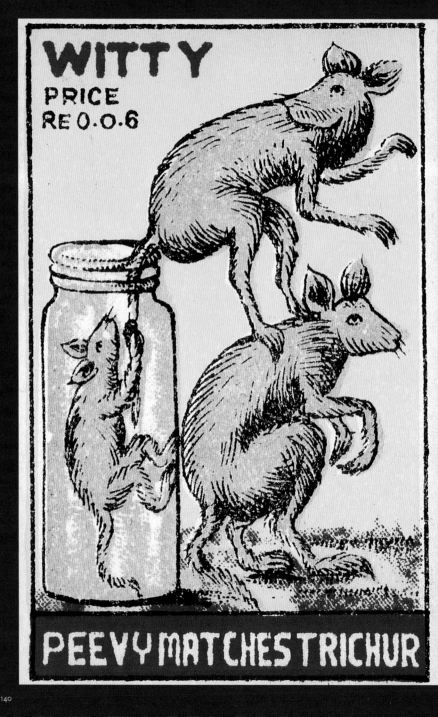

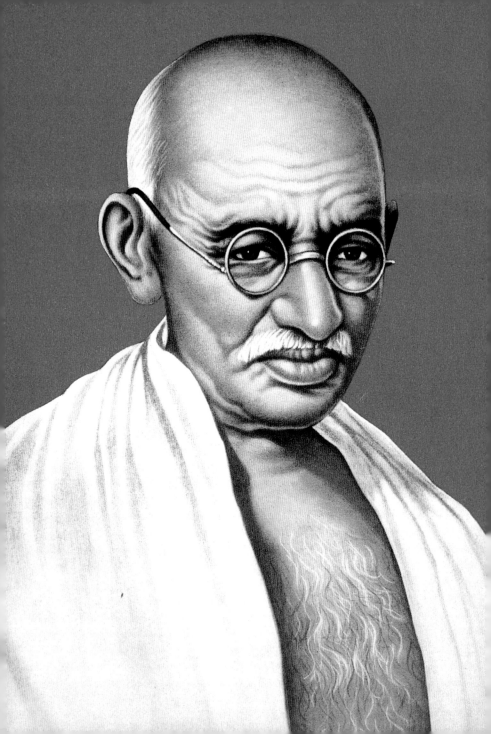

AZADI KE SENANI आज़ादी के सेनानी

 Nana Saheb — नाना साहेब

 Rani Laxmibai — रानी लक्ष्मीबाई

 Bahadur Shah Zafar — बहादुर शाह ज़फ़र

Tantya Tope — तांतिया टोपे

 Raja Rammohun Roy — राजा राममोहन राय

Chittaranjan Das — चितरंजन दास

Bipin Cha... Pal — बिपिन चन्द्र पाल

 Annie Besant — एनी बेसन्ट

Dadabhoy Naoroji — दादा भाई नौरोजी

 Veer Savarkar — वीर दामोदर सावरकर

 Chandra Shekhar Azad — चन्द्र शेखर आज़ाद

Bhagat Singh — भगत सिंह

 Kasturba Gandhi — कस्तूरबा गांधी

 Sarojini Naidu — सरोजिनी नायडू

Abul Kalam Azad — अबुल कलाम आज़ाद

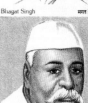 Govind Ballabh Pant — गोविंद बल्लभ पन्त

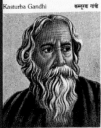 Rabindra Nath Tagore — रबिन्द्र नाथ टैगोर

 Rasbihari Basu — रासबिहारी बसु

 Dr. B. R. Ambedkar — डॉ. भीमराव रामजी अम्बेडकर

 Jai Prakash Narayan — जय प्रकाश नारायण

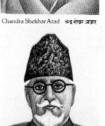

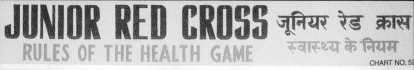

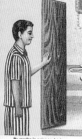

Be regular in going to latrine.
नियमानुसार शौचालय जाना।

Clean your teeth properly every day.
प्रति-दिन अच्छी तरह दांत साफ करना।

Take a bath everyday and dry your body with a clean cloth.
प्रतिदिन स्नान करना तथा शरीर को साफ-सुथरे कपड़े से पोंछना।

Keep your nails short and clean.
नाखून छोटे व साफ रखना।

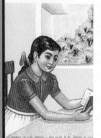

Read in a good light.
अच्छी रोशनी में पढ़ना।

Hold your body straight while standing.
खड़ा रहते समय शरीर को सीधा रखना।

Do not spit on the ground.
फर्श पर न थूकना।

कपड़े में थूकने या छींकने की आदत डालना, तथा नाक साफ करने के लिए रूमाल प्रयोग करना।

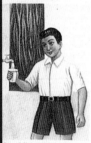

के साथ ताजी दूध की अजवा ताजा खाने से बाद अच्छा चाहिए

Eat plenty of fresh fruits and vegetables.
Chew your food well.
ताजे फल व सब्जियाँ खाना तथा खाना अच्छी तरह चबा कर खाना।

हर 3 साल के बाद टका तथा इसारी में नेचर जाँची हो।
नेचर की जाँच करवाना।

महीने में एक बार अपना तोल तथा साल में दो बार अपना नाप करवाना तथा उसका रिकार्ड रखना।

Form queue habit.
पंक्ति में खड़े होने की आदत डालना।

रेशा काला अपना सिकाइयाँ जिन पर धूप पड़ी हो या सब्जियाँ सीडी हो, कभी भी न खाना।

Play out of doors everyday and always breathe through the nose.
प्रतिदिन खुली हवा में खेलना तथा नाक द्वारा साँस लेना।

प्रतिदिन रात को खिड़कियाँ खोल कर तथा मुँह को ढके बिना 9 से 10 घण्टे तक सोना।

Santhal Dance (Bihar)
संथल-नृत्य (बिहार)

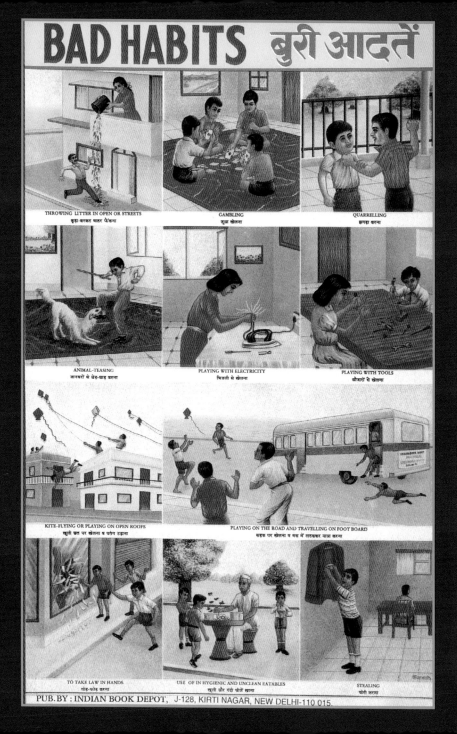

BAD HABITS बुरी आदतें

THROWING LITTER IN OPEN OR STREETS
कूड़ा-करकट बाहर फेंकना

GAMBLING
जुआ खेलना

QUARRELLING
झगड़ा करना

ANIMAL-TEASING
जानवरों से छेड़-छाड़ करना

PLAYING WITH ELECTRICITY
बिजली से खेलना

PLAYING WITH TOOLS
औजारों से खेलना

KITE-FLYING OR PLAYING ON OPEN ROOFS
खुली छत पर खेलना व पतंग उड़ाना

PLAYING ON THE ROAD AND TRAVELLING ON FOOT BOARD
सड़क पर खेलना व बस में लटककर यात्रा करना

TO TAKE LAW IN HANDS
तोड़-फोड़ करना

USE OF IN HYGIENIC AND UNCLEAN EATABLES
खुली और गंदी चीजें खाना

STEALING
चोरी करना

PUB. BY : INDIAN BOOK DEPOT, J-128, KIRTI NAGAR, NEW DELHI-110 015.

ELECTRIC SHAVER
विद्युत चालित हज़ामत यन्त्र

TABLE & CEILING FANS
मेज़ और छत के पंखे

आदर्श बालक
AN IDEAL BOY

CHART NO. 1

सवेरे उठना ।
Gets up early in the morning.

माता-पिता को प्रणाम करना ।
Salutes parents.

सैर करना ।
Goes for Morning Walk.

दाँत साफ करना ।
Brushes up the teeth.

प्रति-दिन नहाना ।
Bathes daily.

प्रार्थना करना ।
PRAYS.

पाठशाला जाना व ध्यानपूर्वक पढ़ना ।
Goes to school & .reads attentively.

समय पर भोजन करना ।
Takes meals in time.

दूसरों की सहायता करना ।
Helps others.

खेल-कूद में भाग लेना ।
Takes part in Games.

एन॰ सी॰ सी॰ में सम्मिलित रहना ।
Joins N. C. C.

सामाजिक कार्यों में भाग लेना ।
Takes part in social activities.

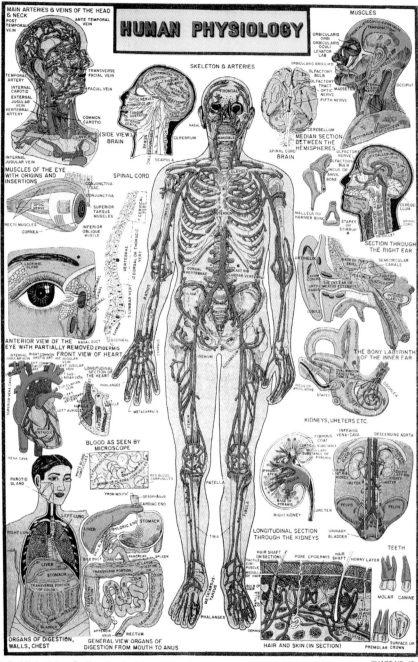

HUMAN PHYSIOLOGY

MAIN ARTERIES & VEINS OF THE HEAD & NECK

MUSCLES

SKELETON & ARTERIES

(SIDE VIEW) BRAIN

MEDIAN SECTION BETWEEN THE HEMISPHERES BRAIN

SECTION THROUGH THE RIGHT EAR

MUSCLES OF THE EYE WITH ORIGINS AND INSERTIONS

SPINAL CORD

THE BONY LABYRINTH OF THE INNER EAR

ANTERIOR VIEW OF THE EYE WITH PARTIALLY REMOVED EPIDERMIS

FRONT VIEW OF HEART

LONGITUDINAL SECTION OF THE HEART

KIDNEYS, URETERS ETC.

BLOOD AS SEEN BY MICROSCOPE

LONGITUDINAL SECTION THROUGH THE KIDNEYS

TEETH

ORGANS OF DIGESTION, WALLS, CHEST

GENERAL VIEW ORGANS OF DIGESTION FROM MOUTH TO ANUS

HAIR AND SKIN (IN SECTION)

Published by: Indian Book Depot (Map House), J-128, Kirti Nagar, New Delhi-15

CHART NO. 47
Rs. 2.00

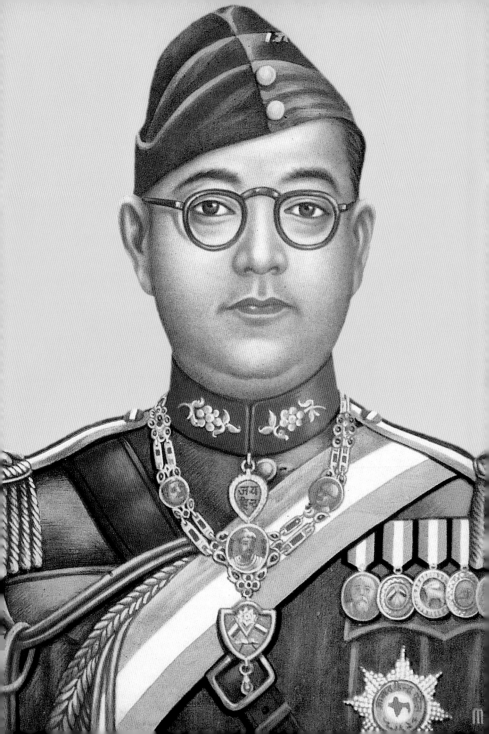

PARTS OF THE BODY शरीर के अंग

CHART NO. 74

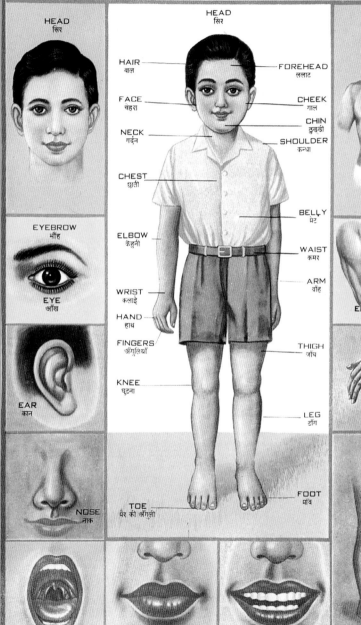

HEAD
सिर

HEAD
सिर

HAIR
बाल

FOREHEAD
ललाट

FACE
चेहरा

CHEEK
गाल

CHIN
ठुड्डी

NECK
गर्दन

SHOULDER
कन्धा

CHEST
छाती

BELLY
पेट

ELBOW
कोहनी

WAIST
कमर

ARM
बाँह

WRIST
कलाई

HAND
हाथ

FINGERS
अंगुलियाँ

THIGH
जाँघ

KNEE
घुटना

LEG
टाँग

FOOT
पाँव

TOE
पैर की अंगुली

EYEBROW
भौंह

EYE
आँख

EAR
कान

NOSE
नाक

MOUTH
मुँह

LIPS
होंठ

TEETH
दाँत

NAVEL
नाभि

ABDOMEN
पेडू

ARM
बाँह

ELBOW
कोहनी

HAND
हाथ

LEGS
टाँगें

FEET
पैर

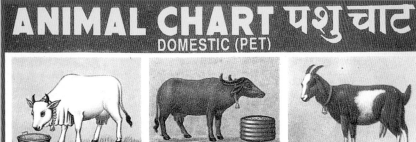

ANIMAL CHART पशु चाट
DOMESTIC (PET)

COW गाय	BUFFALO भैंस	GOAT बकरी
CAT बिल्ली	DOG कुत्ता	HORSE घोड़ा
DONKEY गधा	CAMEL ऊँट	ELEPHANT हाथी
MONKEY बन्दर	PIG सुअर	OX बैल
SHEEP भेड़	RABBIT खरगोश	MONGOOSE नेवला

WASHING MACHINE
कपड़े धोने की मशीन

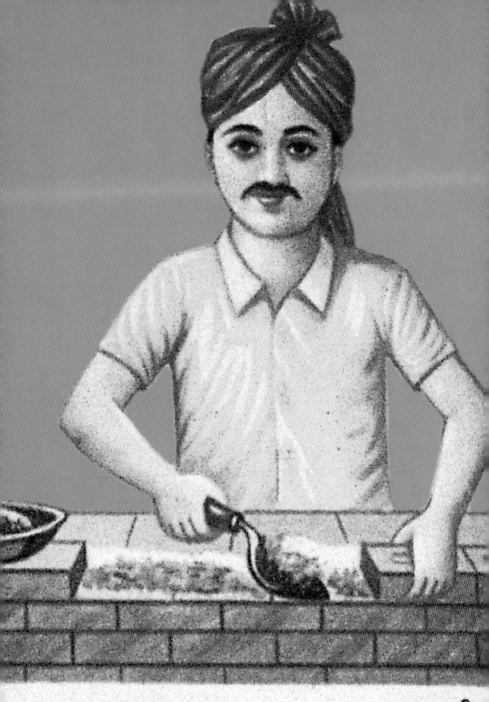

MASON राजगि

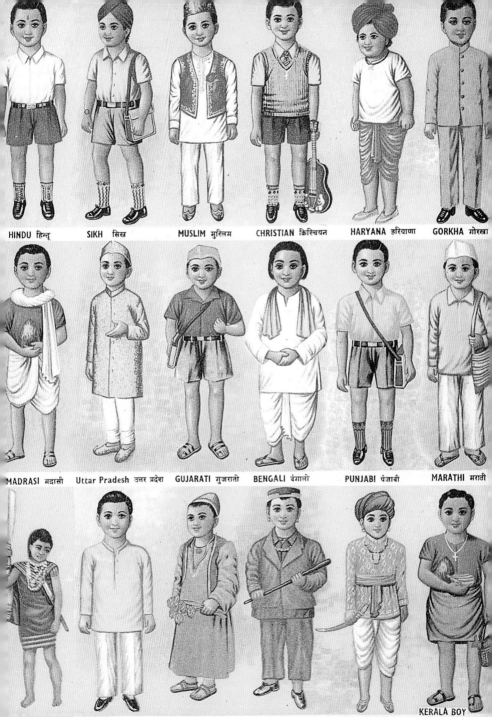

HINDU हिन्दू SIKH सिख MUSLIM मुस्लिम CHRISTIAN क्रिस्चियन HARYANA हरियाणा GORKHA गोरखा

MADRASI मदरासी Uttar Pradesh उत्तर प्रदेश GUJARATI गुजराती BENGALI बंगाली PUNJABI पंजाबी MARATHI मराठी

NAGA नागा BIHARI बिहारी KASHMIRI काश्मीरी Himachal Pradesh हिमाचल प्रदेश RAJATHANI राजस्थानी KERALA BOY केरल का बच्चा

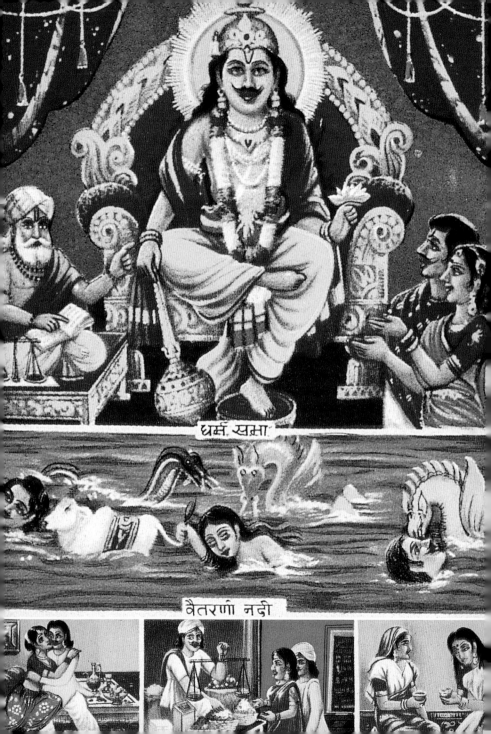

धर्म सभा

वैतरणी नदी

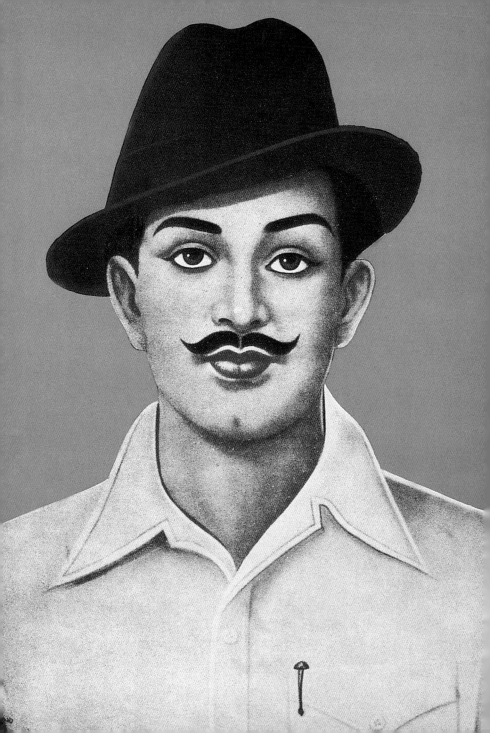

BEAKS AND PAWS OF BIRDS

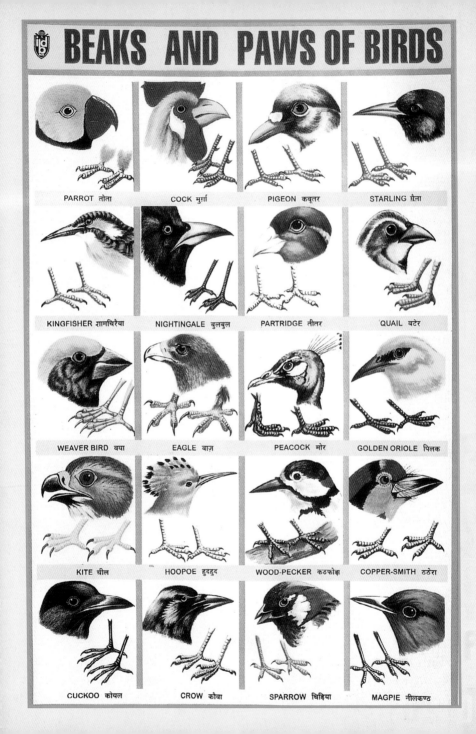

PARROT तोता	COCK मुर्गा	PIGEON कबूतर	STARLING मैना
KINGFISHER रामचिरैया	NIGHTINGALE बुलबुल	PARTRIDGE तीतर	QUAIL बटेर
WEAVER BIRD बया	EAGLE बाज़	PEACOCK मोर	GOLDEN ORIOLE पिलक
KITE चील	HOOPOE हुदहुद	WOOD-PECKER कठफोड़ा	COPPER-SMITH ठठेरा
CUCKOO कोयल	CROW कौवा	SPARROW चिड़िया	MAGPIE नीलकण्ठ

हिन्दी वर्णमाला चार्ट

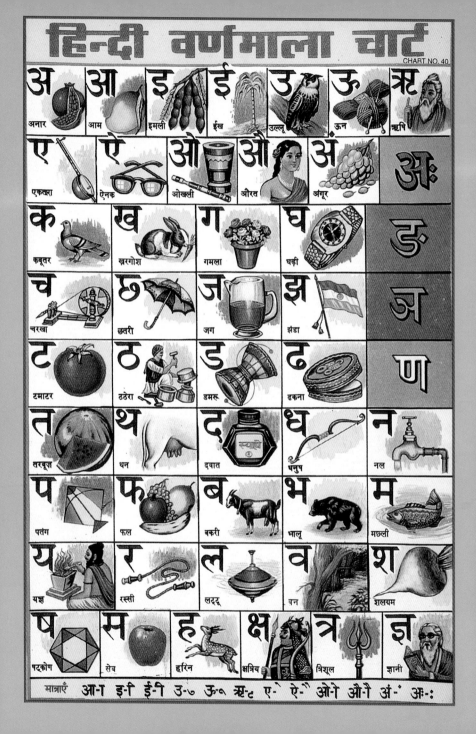

अ	आ	इ	ई	उ	ऊ	ऋ
अनार	आम	इमली	ईख	उल्लू	ऊन	ऋषि

ए	ऐ	ओ	औ	अं	अः	अं
एकतारा	ऐनक	ओखली	औरत	अंगूर		

क	ख	ग	घ		ङ
कबूतर	खरगोश	गमला	घड़ी		

च	छ	ज	झ		ञ
चरखा	छतरी	जग	झंडा		

ट	ठ	ड	ढ		ण
टमाटर	ठठेरा	डमरू	ढकना		

त	थ	द	ध	न
तरबूज़	थन	दवात	धनुष	नल

प	फ	ब	भ	म
पतंग	फल	बकरी	भालू	मछली

य	र	ल	व	श
यज्ञ	रस्सी	लट्टू	वन	शलगम

ष	स	ह	क्ष	त्र	ज्ञ
षट्कोण	सेब	हिरन	क्षत्रिय	त्रिशूल	ज्ञानी

मात्राएँ आ-ा इ-ि ई-ी उ-ु ऊ-ू ऋ-ृ ए-े ऐ-ै ओ-ो औ-ौ अं-ं अः-ः

ਪ

ਪੱਤਾ

ਢ

ਫਲ

ੳ

ਤ

ਤੱਕੜੀ

ਬ

ਘਟ

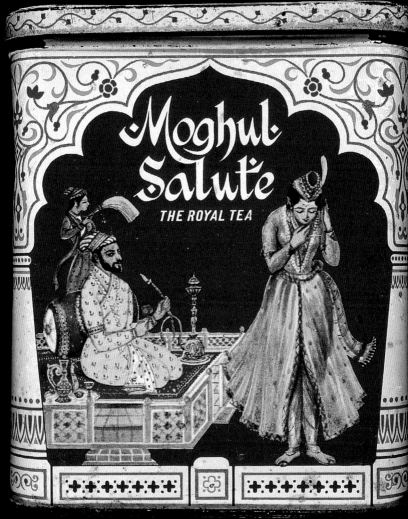

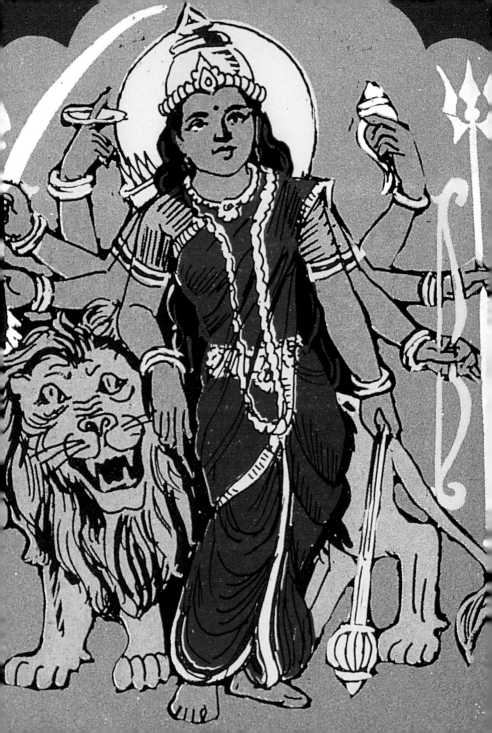

SHREE MAHALAKSHMI APPALAMS MADRAS-4

SMS

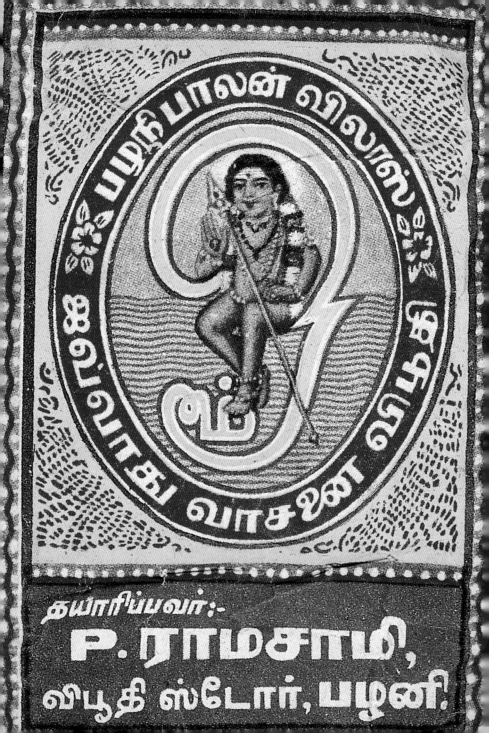

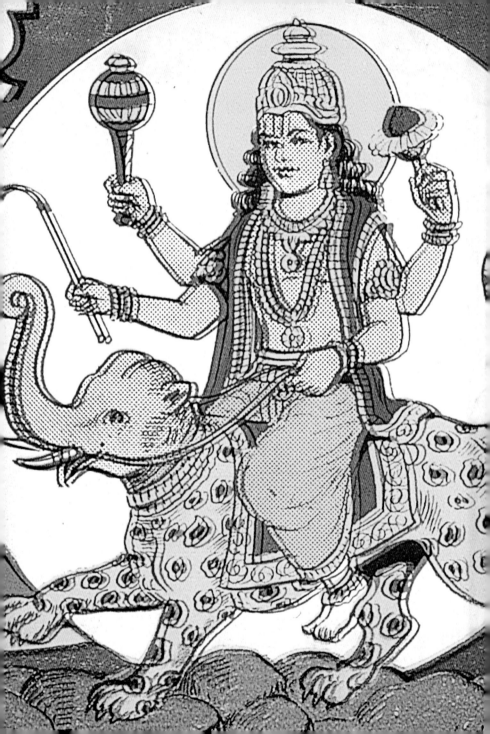

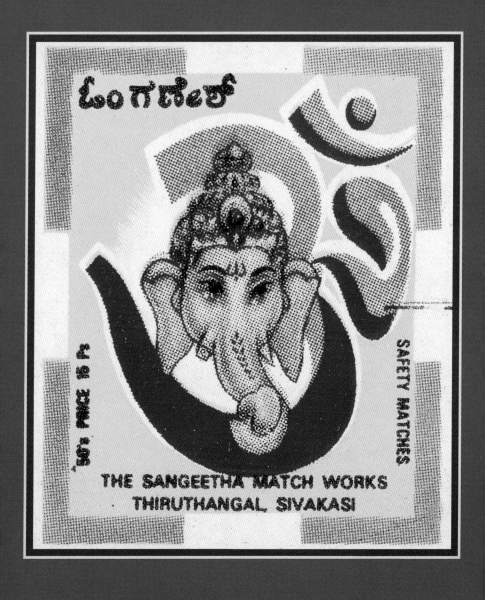

SAFETY MATCHES

THE SANGEETHA MATCH WORKS
THIRUTHANGAL, SIVAKASI

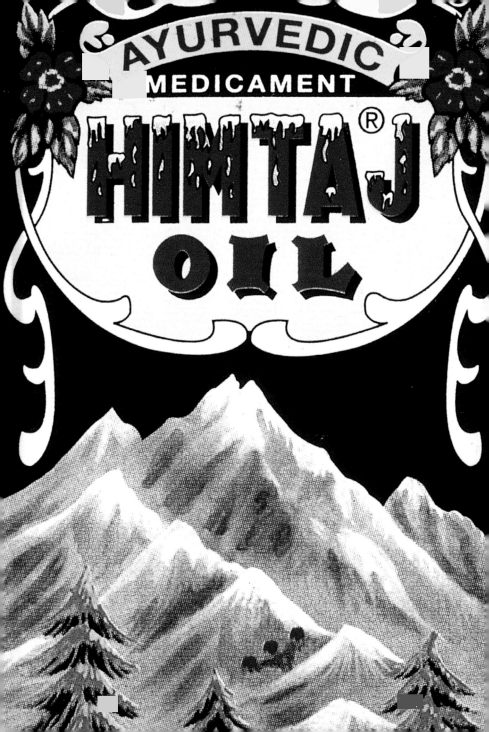

Tibet Snow

NO MATTER HOW ROUGH WORK YOU HAVE TO DO. REGULAR USE OF TIBET SNOW WILL KEEP YOUR HANDS SMOOTH AND VELVETY.

USE OF TIBET SNOW AFTER SHAVE WILL AVOID IRRITATION IN MINOR CUTS AND INFLAMMATION IN THE SKIN. TIBET IS A PREVENTION AGAINST BLACKHEADS AND PIMPLES.

COLLEGE GIRLS LOVE TIBET SNOW. ITS USE NOT ONLY MAKES FACES CHARMING AND FASCINATING BUT KEEPS OFF DUST.

TIBET SNOW TURNS UNPLEASANT ODOUR OF PERSPIRATION IN ARMPITS INTO MOST DESIRABLE FLAVOUR.

SPORTSMEN USE TIBET SNOW BEFORE GOING TO AND AFTER COMMING FROM PLAYGROUND. IN THE FORMER CASE TIBET SNOW MAKES SKIN DUST-PROOF. IN THE LATTER CASE SMALL PARTICLES OF DUST ARE REMOVED VERY CONVENIENTLY. HENCE SKIN REMAINS FREE FROM ALL DISEASES.

AFTER LONG WALK, MASSAGE OF TIBET SNOW ON FEET NOT ONLY KEEPS SKIN NATURAL SOFT BUT IT IS A PREVENTION AGAINST CORNS PARTICULARLY IN OLD AGE.

NOTE: IF THE SNOW GETS HARD OWING TO CLIMATIC EFFECTS. A SMALL QUANTITY OF SLIGHTLY WARM WATER MAY BE MIXED AND THIS WILL BRING THE SNOW TO ITS ORIGINAL QUALITY.

KOHINOOR CHEMICAL CO. (PVT.) LTD. KARACHI

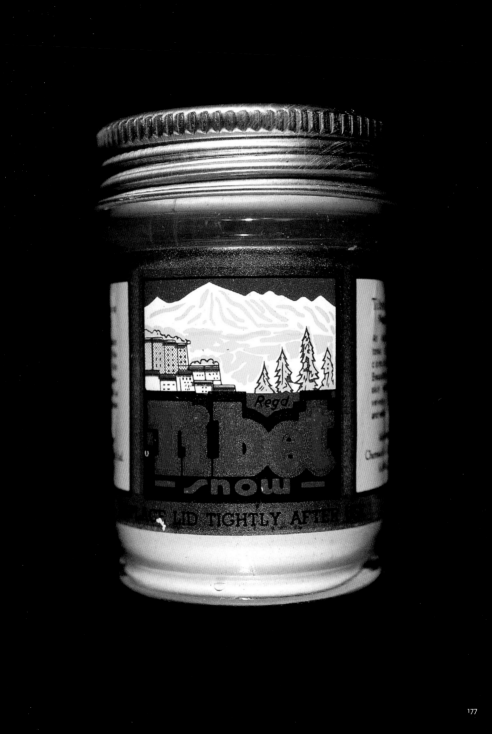

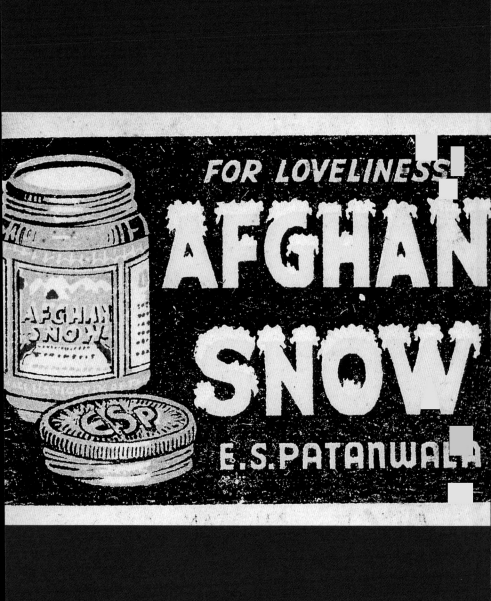

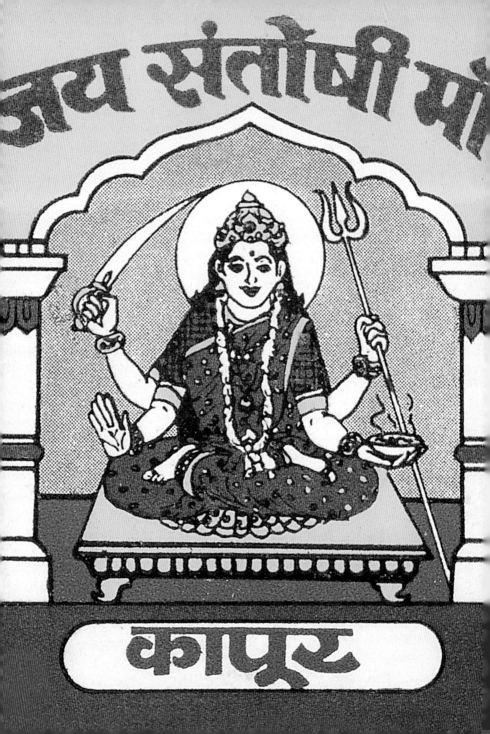

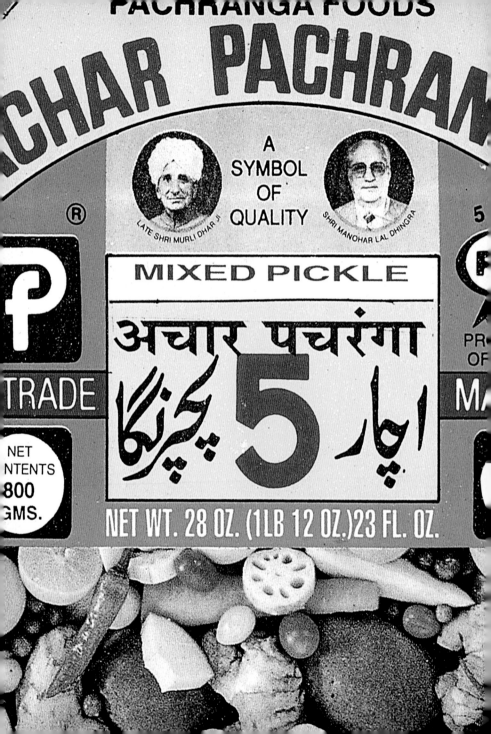

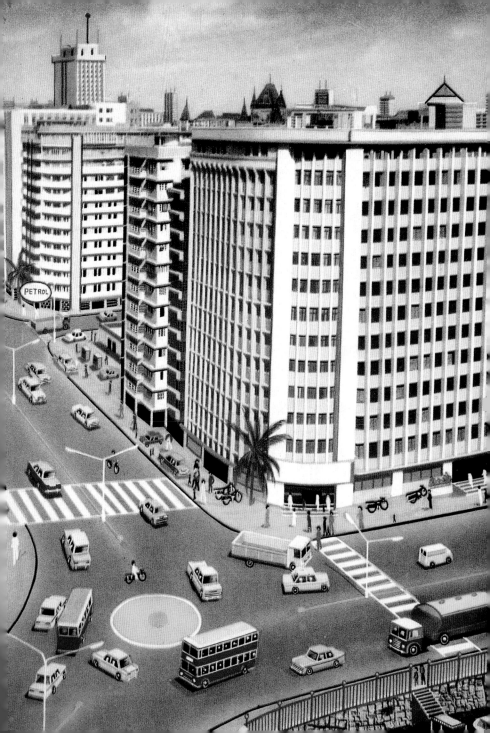

PETROL

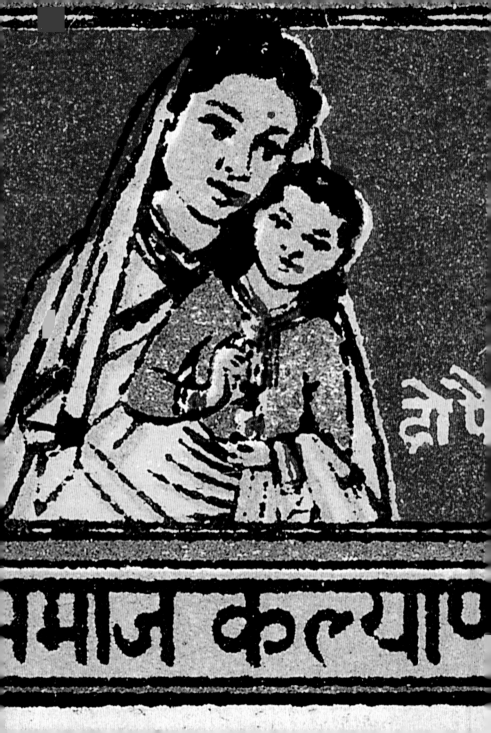

समाज कल्याण

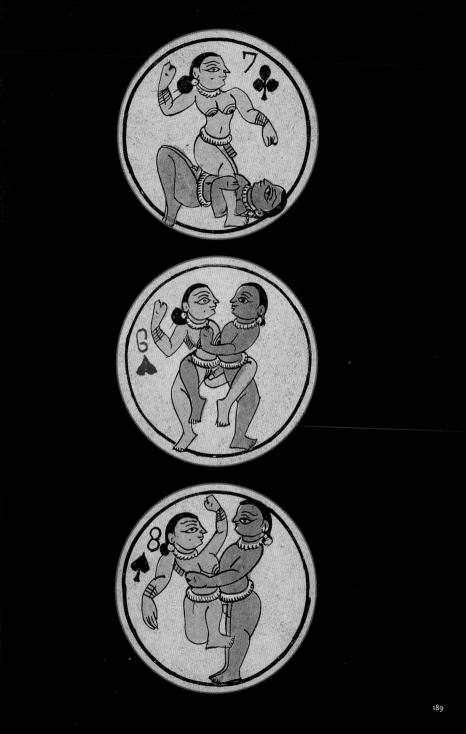

Identification of works by page number

Sharan, Indian Book Depot Publishers **162** *Hindi Varnamala Chart* (Hindi alphabet chart), Educational chart, Indian Book Depot Publishers **163–65** Children's alphabet book pages, Swan Publishers, Jalandhar **166** *Sri Shani Chalisa (Prayer to God Shani)*, Prayer book, Garg & Co. Publishers **167** Tin tea box **168** *Ath Sri Devi Sahasra Namavali (Prayer to the Goddess)*, Prayer book, Triveni Publishers **169** Packaging label for *papads* **170** Packaging label for Laxmi incense **171** Packaging label depicting Lord Murugan **172** *Brihaspathi Parivaar*, Prayer book **173** Matchbox label **174–75** Packaging labels for Hintaj Ayurvedic oil **176–77** Instruction insert and packaging label for Tibet Snow cold cream **178–79** Matchbox labels **180** Packaging label for Jai Santhoshi Maa Camphor **181–85** Incense box packaging **186** Pickle tin **187** *Building Scene*, Framing picture, Associated Calendars Publishers **188** *Samaj Kalyan (Social Welfare)*, Matchbox label (detail) **189** Hand-painted circular erotic playing cards

Samantha Harrison is an artist and collector living in Los Angeles, California, who has exhibited her paintings in the United States and abroad. **Bari Kumar** was born in India and studied graphic design at Otis/Parsons School of Design, Los Angeles. His paintings have been exhibited in galleries and museums internationally, and he is the recipient of an Emmy® for his work as the color supervisor of the animated show *Futurama*. Together, Harrison and Kumar have been collecting Indian graphics during their many trips to India with their son, Siddarth.

Kajri Jain worked as a graphic designer before gaining a doctorate in Art History from the University of Sydney. She is currently writing a book on Indian calendar art entitled *Gods in the Bazaar*.

Our sincere gratitude to our parents in the U. S. and in India for their unconditional support. Thanks to Kajri Jain for sharing her research and knowledge in this subject. Thanks to Nina Wiener and everyone at TASCHEN for their professionalism. Finally to Jim Heimann, who has been a teacher, mentor and a friend since our college years, thank you, thank you, thank you!
Sam & Bari

All-American Ads of the 40s
W.R. Wilkerson III, Ed. Jim
Heimann / Flexi-cover, 768 pp. /
€ 29.99 / $ 39.99 / £ 19.99 /
¥ 4.900

All-American Ads of the 50s
Ed. Jim Heimann / Flexi-cover,
928 pp. / € 29.99 / $ 39.99 /
£ 19.99 / ¥ 4.900

All-American Ads of the 60s
Steven Heller, Ed. Jim Heimann /
Flexi-cover, 960 pp. / € 29.99 /
$ 39.99 / £ 19.99 / ¥ 4.900

"The ads do more than advertise products – they provide a record of American everyday life of a bygone era in a way that nothing else can." —*Associated Press*, USA

"Buy them all and add some pleasure to your life."

All-American Ads 40ˢ
Ed. Jim Heimann

All-American Ads 50ˢ
Ed. Jim Heimann

All-American Ads 60ˢ
Ed. Jim Heimann

Angels
Gilles Néret

Architecture Now!
Ed. Philip Jodidio

Art Now
Eds. Burkhard Riemschneider,
Uta Grosenick

Atget's Paris
Ed. Hans Christian Adam

Best of Bizarre
Ed. Eric Kroll

Bizarro Postcards
Ed. Jim Heimann

Karl Blossfeldt
Ed. Hans Christian Adam

California, Here I Come
Ed. Jim Heimann

50ˢ Cars
Ed. Jim Heimann

Chairs
Charlotte & Peter Fiell

Classic Rock Covers
Michael Ochs

Description of Egypt
Ed. Gilles Néret

Design of the 20ᵗʰ Century
Charlotte & Peter Fiell

Design for the 21ˢᵗ Century
Charlotte & Peter Fiell

Dessous
Lingerie as Erotic Weapon
Gilles Néret

Devils
Gilles Néret

Digital Beauties
Ed. Julius Wiedemann

Robert Doisneau
Ed. Jean-Claude Gautrand

Eccentric Style
Ed. Angelika Taschen

Encyclopaedia Anatomica
Museo La Specola, Florence

Erotica 17ᵗʰ–18ᵗʰ Century
From Rembrandt to Fragonard
Gilles Néret

Erotica 19ᵗʰ Century
From Courbet to Gauguin
Gilles Néret

Erotica 20ᵗʰ Century, Vol. I
From Rodin to Picasso
Gilles Néret

Erotica 20ᵗʰ Century, Vol. II
From Dalí to Crumb
Gilles Néret

Future Perfect
Ed. Jim Heimann

The Garden at Eichstätt
Basilius Besler

HR Giger
HR Giger

Homo Art
Gilles Néret

Hula
Ed. Jim Heimann

India Bazaar
Samantha Harrison,
Bari Kumar

Indian Style
Ed. Angelika Taschen

Industrial Design
Charlotte & Peter Fiell

Kitchen Kitsch
Ed. Jim Heimann

Krazy Kids' Food
Eds. Steve Roden,
Dan Goodsell

Las Vegas
Ed. Jim Heimann

London Style
Ed. Angelika Taschen

Male Nudes
David Leddick

Man Ray
Ed. Manfred Heiting

Mexicana
Ed. Jim Heimann

Native Americans
Edward S. Curtis
Ed. Hans Christian Adam

New York Style
Ed. Angelika Taschen

**Extra/Ordinary Objects,
Vol. I**
Ed. Colors Magazine

**Extra/Ordinary Objects,
Vol. II**
Ed. Colors Magazine

15ᵗʰ Century Paintings
Rose-Marie & Rainer Hagen

16ᵗʰ Century Paintings
Rose-Marie & Rainer Hagen

Paris-Hollywood
Serge Jacques
Ed. Gilles Néret

Penguin
Frans Lanting

Photo Icons, Vol. I
Hans-Michael Koetzle

Photo Icons, Vol. II
Hans-Michael Koetzle

20ᵗʰ Century Photography
Museum Ludwig Cologne

Pin-Ups
Ed. Burkhard Riemschneider

Giovanni Battista Piranesi
Luigi Ficacci

Provence Style
Ed. Angelika Taschen

Pussy Cats
Gilles Néret

Redouté's Roses
Pierre-Joseph Redouté

Robots and Spaceships
Ed. Teruhisa Kitahara

Seaside Style
Ed. Angelika Taschen

See the World
Ed. Jim Heimann

Eric Stanton
Reunion in Ropes & Other
Stories
Ed. Burkhard Riemschneider

Eric Stanton
She Dominates All & Other
Stories
Ed. Burkhard Riemschneider

Tattoos
Ed. Henk Schiffmacher

Tuscany Style
Ed. Angelika Taschen

Edward Weston
Ed. Manfred Heiting

Women Artists
in the 20ᵗʰ and 21ˢᵗ Century
Ed. Uta Grosenick

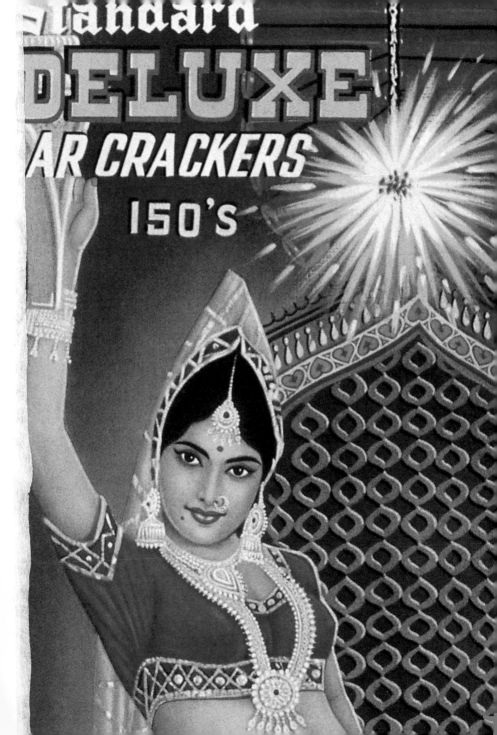